MONTEVERDE & ARENAL

COSTA RICA — REGIONAL GUIDES

María Montero and Luciano Capelli

AN OJALÁ EDICIONES & ZONA TROPICAL PUBLICATION
from
COMSTOCK PUBLISHING ASSOCIATES
an imprint of
CORNELL UNIVERSITY PRESS
ITHACA AND LONDON

First published 2019 by Cornell University Press

Printed in China

Library of Congress Cataloging-in-Publication Data

Names: Montero, María (Travel writer), author. | Capelli, Luciano, author.
Title: Monteverde & Arenal / María Montero and Luciano Capelli.
Other titles: Monteverde and Arenal
Description: Ithaca : Comstock Publishing Associates, an imprint of Cornell
University Press, 2019. | Series: Costa Rica regional guides |
"An Ojalá Ediciones & Zona Tropical publication." | Includes index.
Identifiers: LCCN 2019008048 | ISBN 9781501739286 (pbk. ; alk. paper)
Subjects: LCSH: Puntarenas (Costa Rica : Province)—Description and travel.
| Alajuela (Costa Rica : Province)—Description and travel. | Monteverde
Cloud Forest Preserve (Costa Rica) | Arenal, Lake, Region (Costa Rica)
Classification: LCC F1549.P86 M66 2019 | DDC 917.286/704—dc23
LC record available at https://lccn.loc.gov/2019008048

Front cover photo: Diego Mejías
Back cover photo: Jeffrey Muñoz

COSTA RICA REGIONAL GUIDES

The world knows Costa Rica as a peaceful and environmentally conscious country that continues to attract several million tourists a year, yet this image may obscure a social and biological legacy that very few visitors get to know.

We hope that the six books in this collection will reveal a reality beyond the apparent one. These are meant to pique the curiosity of travelers through stories about nature, geology, history, and culture, all of which help explain Costa Rica as it exists today.

Each title is dedicated to those who fought, and continue to fight, with grace and wisdom, for a natural world that lies protected, in a state of balance, and accessible to all, in other words, one that is closer to the ideal we seek to make real.

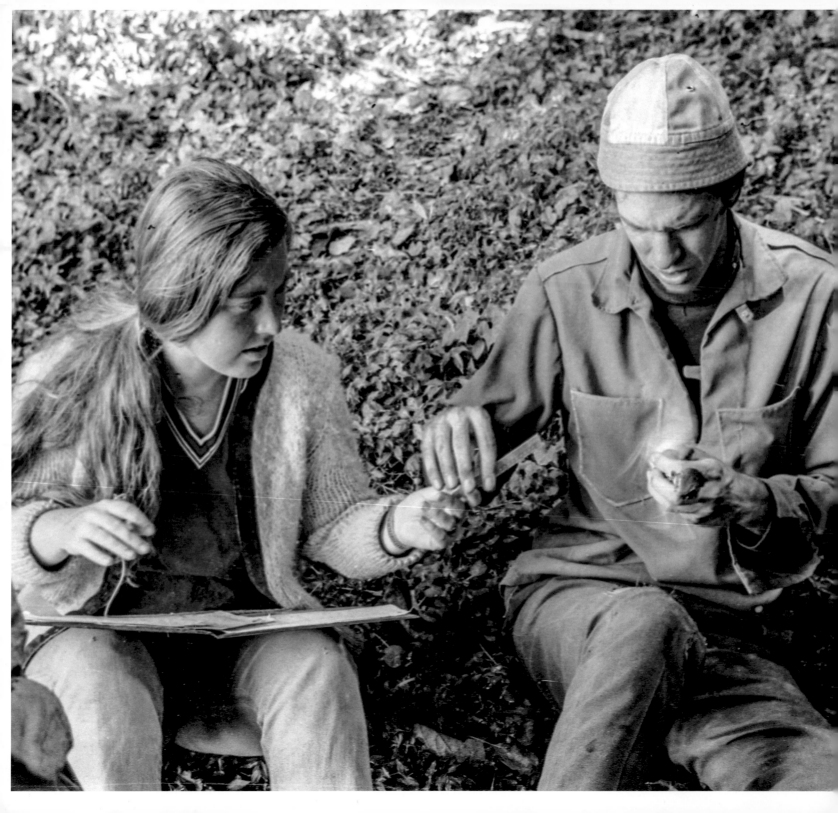

CONTENTS

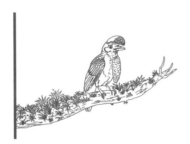
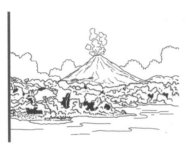
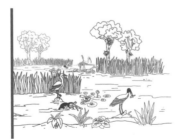

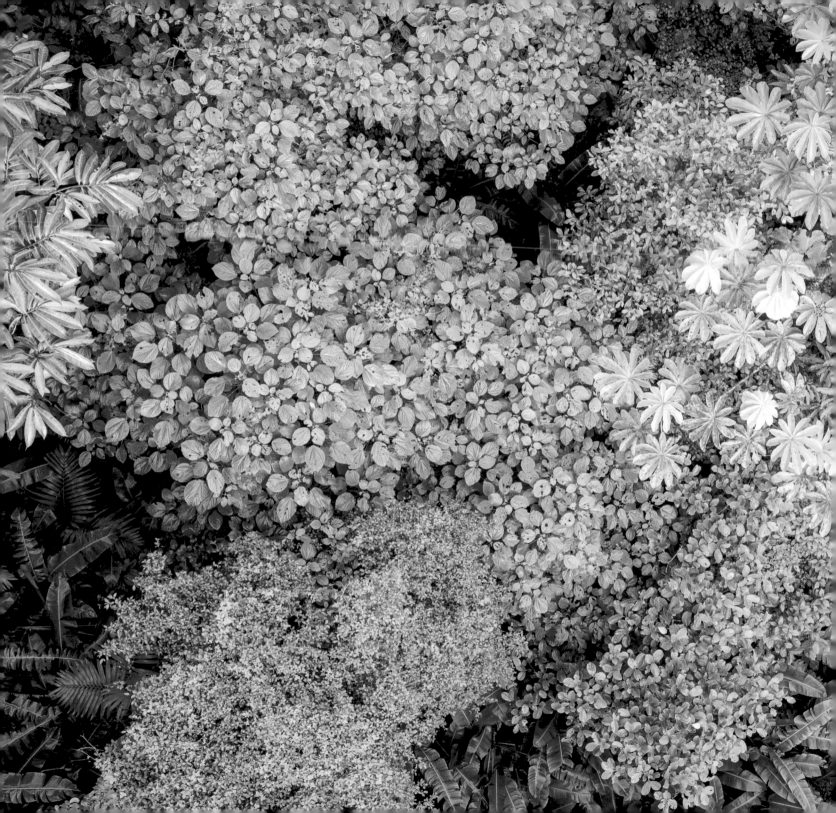

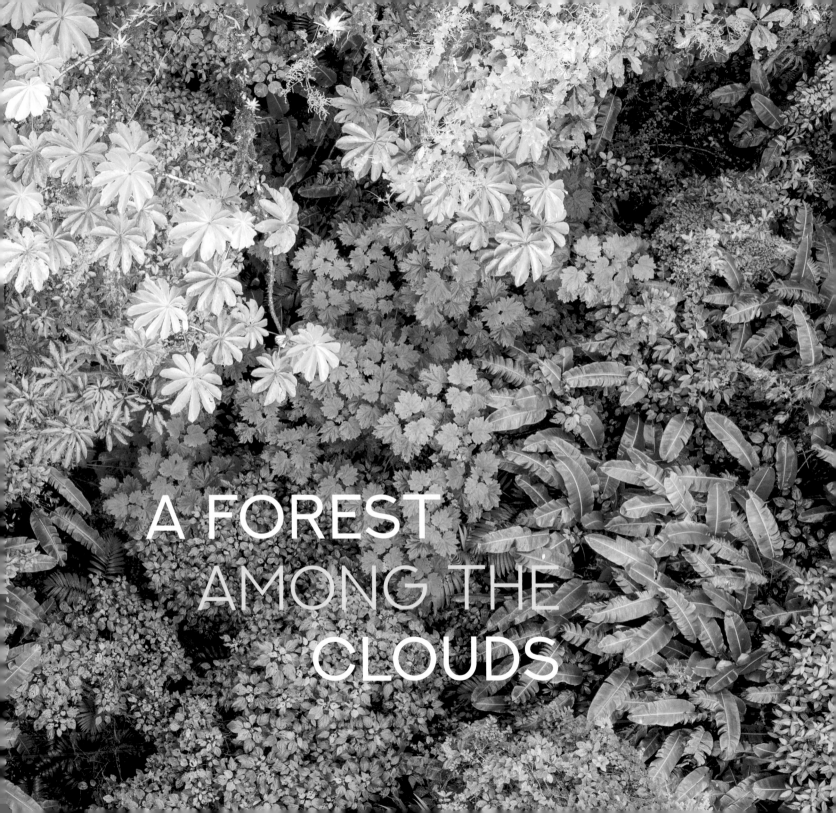

A FOREST
AMONG THE
CLOUDS

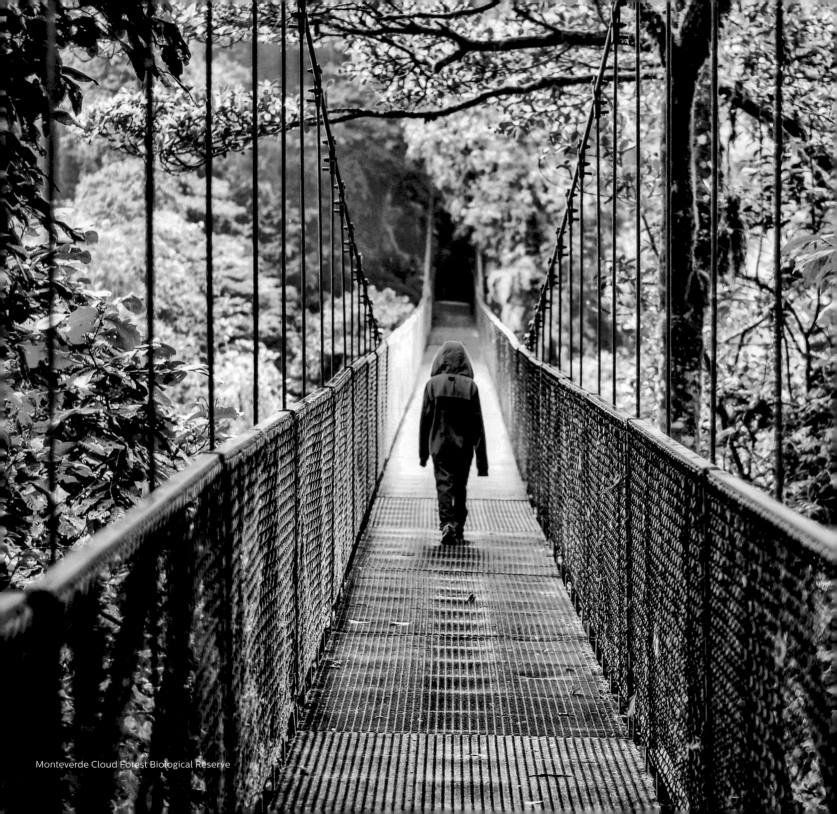

Monteverde Cloud Forest Biological Reserve

As far as the eye can see, the landscape is a playful jumble. Small mountains climb on the shoulders of larger mountains, forming an unending chain of slopes that leapfrog one another until they become lost in the bluish mist that conceals a forest so exuberant it seems to harbor the life of all forests put together.

This is the cloud forest, one of the most unusual ecosystems in the tropics. Acting like a sponge, it absorbs the nearly constant fog that envelopes the forest; condenses, filters, and stores it; and then cascades the water into the surrounding lowlands. It thus feeds countless rivers and streams that, sooner or later, flow into the Caribbean Sea or the Pacific Ocean.

Situated in the Tilarán Mountain Range, Monteverde is home to one of the most visited cloud forests in the world. Although it is composed of fewer than 21 square miles (54 km²), it sustains abundant flora and fauna. The area is so diverse that, based on the classification system defined by botanist and climatologist Leslie Holdridge, 7 of the 12 life zones found in Costa Rica are represented in it.

One of the reasons for this abundance is that the Monteverde and Arenal ecosystems straddle the Continental Divide. As a result they are affected by both the moist weather on the Caribbean slope and the very hot, dry weather on the Pacific slope. Both slopes are influenced by climatic and geographic factors that, together, produce temperature and humidity gradients that vary greatly over short distances.

Its seemingly unending list of endemic flora and fauna also arises from its geographic isolation, which hinders the movement of species (and their genes) and thus leads to the creation of new species.

Established by the Tropical Science Center in 1972 as an outdoor laboratory, the Monteverde Cloud Forest Biological Reserve (or Monteverde Reserve) is perhaps the most famous cloud forest reserve in the world and certainly among the most important of the protected areas in Costa Rica that are privately owned. Its 35,000 acres (14,165 hectares) are part of a continuous expanse of forest that, including public and private lands, covers almost 200,000 acres (80,950 hectares).

One of its neighbors, the Children's Eternal Forest, greatly extends the limits of Monteverde. Created in 1986 by the Monteverde Conservation League (MCL), a group of community residents and visitors, its initial focus was land purchase to address the deforestation that threatened the Peñas Blancas Valley, on the Caribbean slope. But soon after, it shifted its focus to education and research.

A year after having been founded, the Monteverde Conservation League's fundraising campaign drew the attention of Sweden. The idea of saving the cloud forest quickly spread among Swedish children, who shared their enthusiasm with an even larger community of students in the United States, Germany, and Japan. By selling cookies and recycling aluminum cans, the children were able to buy about 15 acres (6 hectares) of forest; and donors from more than 40 countries contributed additional funds that allowed the league to consolidate the nearly 57,000 acres (23,000 hectares) that connect the Monteverde Reserve with Arenal Volcano National Park.

The Monteverde Cloud Forest Biological Reserve began to enjoy worldwide fame thanks to discoveries of creatures such as the golden toad (*Incilius periglenes*). These tiny gemlike amphibians were reported for the first time in 1963 by Jerry James, a community member with a passion for biology who, on observing these amphibians in the forest at over 5000 feet (1600 m) above sea level, persuaded two herpetologists from the Organization for Tropical Studies (OTS) to seek them out: Norma J. Scott and Jay M. Savage.

Once identified as a new species, endemic to an elfin forest on the peaks of the Tilarán Mountain Range, this toad caught the attention of the scientific community worldwide and became the first emblematic species of Monteverde. Sadly, a mere 25 years separate its discovery and its last sighting, in 1989. The species was declared extinct in 2004, after multiple attempts to prove the contrary.

The first sighting of golden toad was not an isolated incident; the 1960s was a decade of environmental awakening in Costa Rica, led by enthusiastic scientists and international organizations that discovered the country's potential for research as well as the consequences of the unrestricted use of natural resources.

Although settlers in this region had begun to arrive since the early 20th century, the most notable were a small band of Quakers from the United States, the majority from Fairhope, Alabama. They were committed pacifists, conscientious objectors to the Korean War, whose leaders had been tried and sentenced to prison in their country for refusing to participate in this conflict and to contribute tax dollars to the military. Why did they choose Costa Rica? At the time, it was the only country in the world that had no army.

The first group of families, composed of fewer than 40 people, arrived in Monteverde in May of 1951, distributing among themselves the 3500 acres (1415 hectares) that they had purchased from the Guacimal Land Company.

The Quakers cut down parts of the forest, leaving their footprints in the heart of the jungle, but preserved one-third of the original land purchase to protect the springs that feed the Guacimal River. In doing this, it should be noted, they sought not wealth but livelihoods. In place of accumulation, exploitation, or speculation, they chose solidarity, sacrifice, and the common good.

"When the Quakers took over the stewardship of the land they called Monteverde, their goal, regardless of the remoteness of the region, was to create a fruitful existence," write Kay Chornook and Wolf Guindon in their book *Walking with Wolf.* "They were visionaries, willing to work hard to cut a productive community out of the wilderness. Guiding their decision-making were concerns for their children's future. They were proud and enthusiastic about their mission."

The scientific "migration" to Monteverde began a decade after the arrival of the Quakers. By this time biologists in the United States had begun to hear about this outdoor laboratory with misty ridges swept by trade winds. These new researchers, many of whom would become residents, were welcomed by the farming community and managed to adapt to conditions that often made it difficult to carry out their research.

In the 1970s, it became evident that the Quakers and the community of biological researchers shared common concerns. While one group depended on the natural world for their livelihood and the other spent their days studying it, both were committed to conserving it.

George Powell and Harriett McCurdy arrived in Monteverde in April of 1970 and rented a small cabin from Wolf and Lucky Guindon. They intended to earn their doctorates by studying the behavior of mixed-species flocks of birds, but were immediately alarmed by the deforestation that was consuming the region.

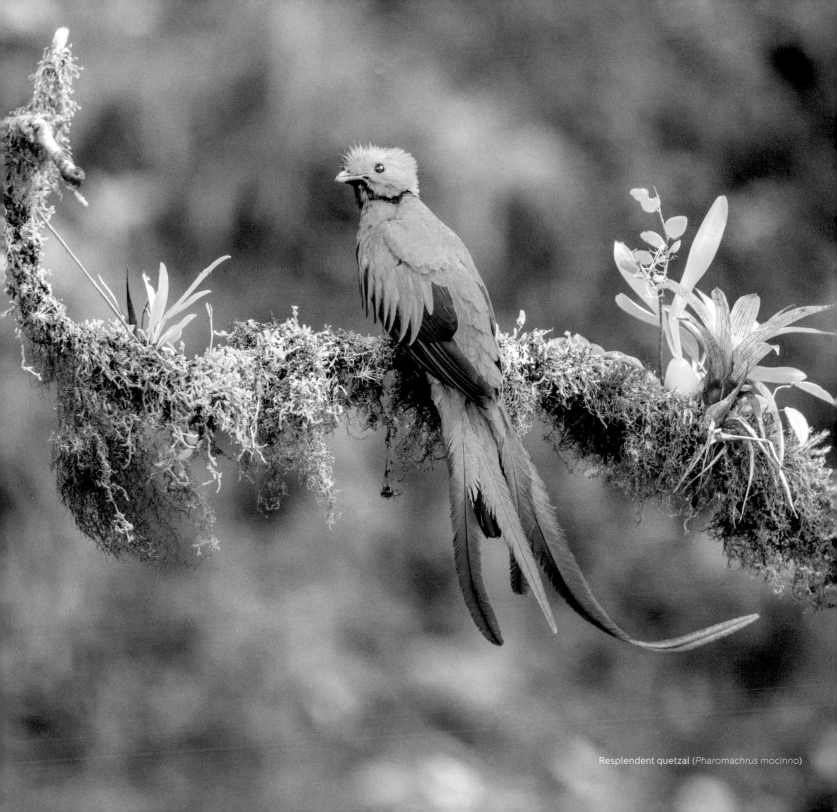

Resplendent quetzal (*Pharomachrus mocinno*)

Wolf, who had spent years clearing the forest and selling chainsaws, had begun to notice—on his untiring walks over the mountains—the changes being made by human activity: the disappearance of species, droughts, and landslides. In him, George and Harriett would find a valuable ally and together they took action, converting loggers into park guards, introducing to farmers the concept of a *reserve*, raising funds internationally, and buying the properties that would become the Monteverde Cloud Forest Biological Reserve.

George continued doing research and publishing important papers, pioneering the use of transmitters to study the migration, mating, and nesting of quetzals and bellbirds. Due to his efforts—and those of his wife—the unique community of Monteverde continues to exist today. It is one of the most peaceful towns in Costa Rica, where a large community of scientists, artists, and conservationists share daily decisions with farmers, dairy producers, and coffee growers.

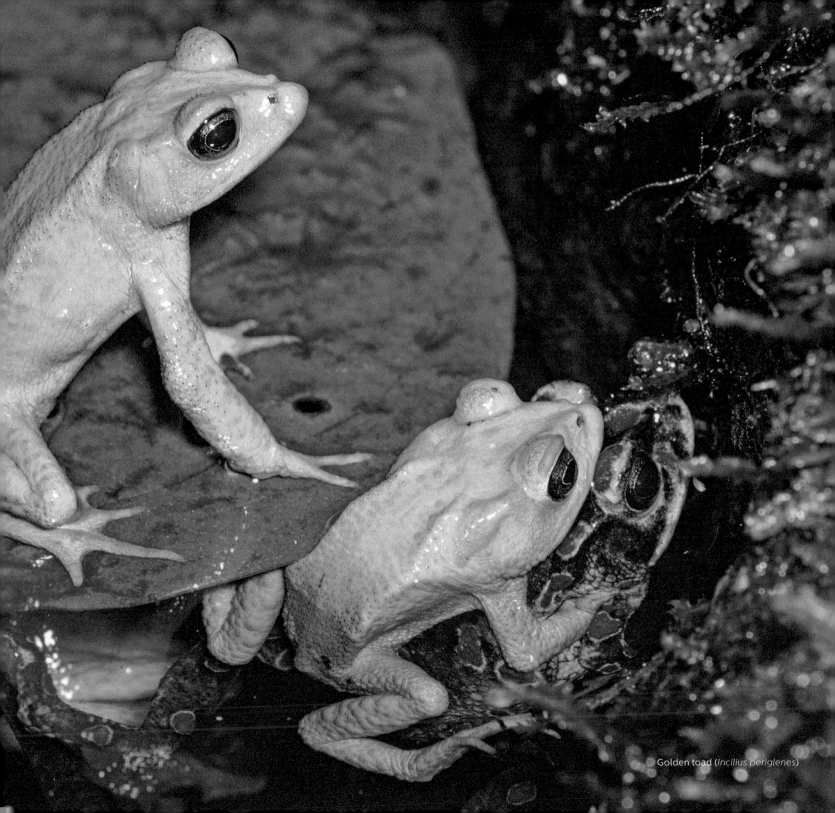
Golden toad (*Incilius periglenes*)

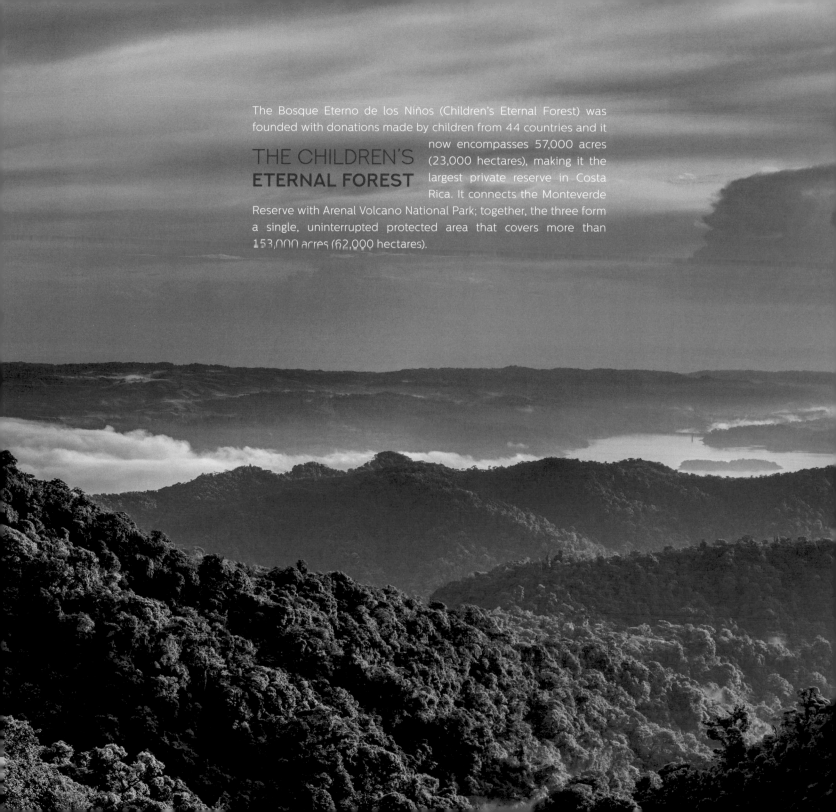

THE CHILDREN'S
ETERNAL FOREST

The Bosque Eterno de los Niños (Children's Eternal Forest) was founded with donations made by children from 44 countries and it now encompasses 57,000 acres (23,000 hectares), making it the largest private reserve in Costa Rica. It connects the Monteverde Reserve with Arenal Volcano National Park; together, the three form a single, uninterrupted protected area that covers more than 153,000 acres (62,000 hectares).

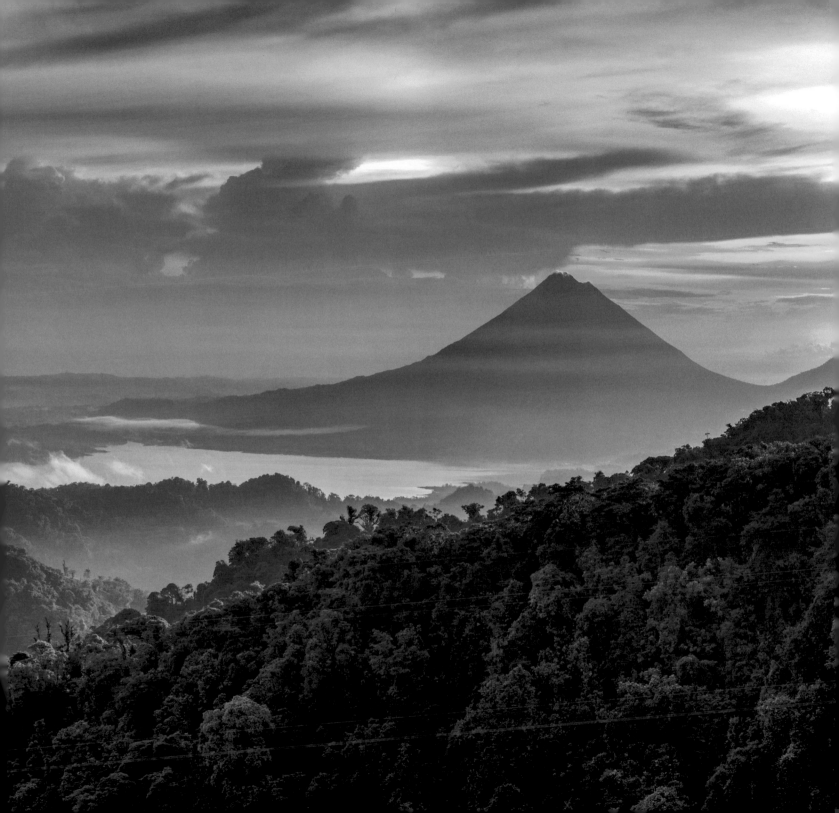

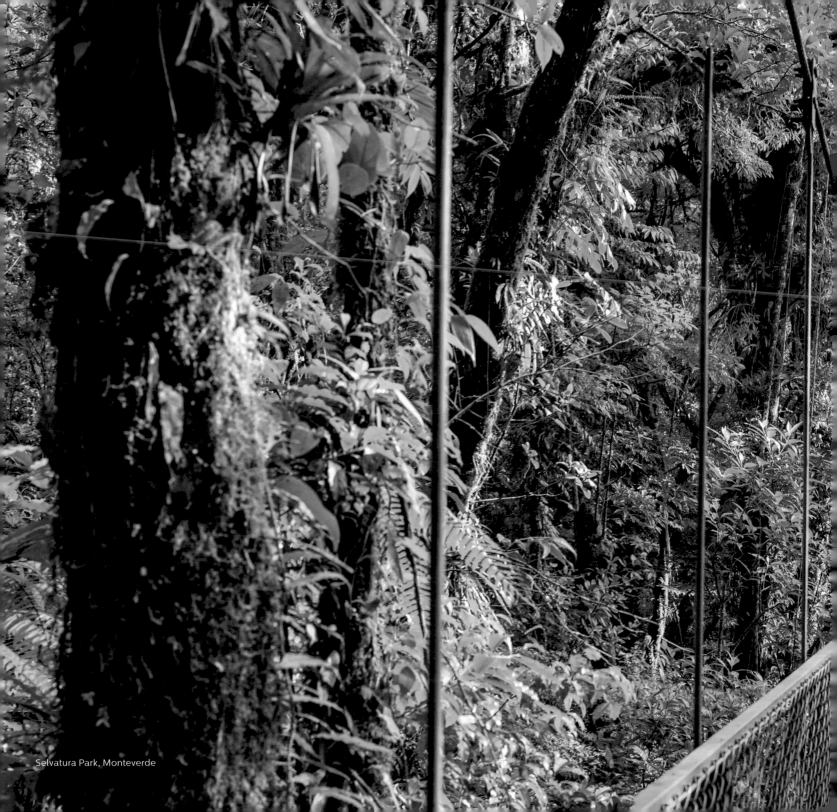

Selvatura Park, Monteverde

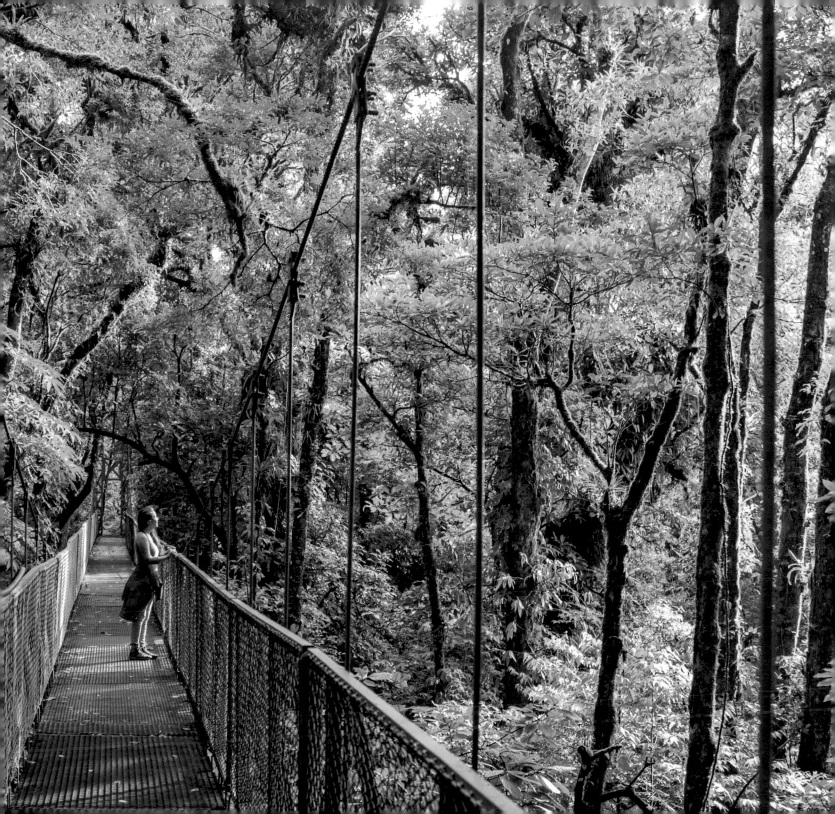

BIRD'S-EYE
VIEW

Its suspended bridges are one of the most popular attractions of Monteverde and Arenal. From them, you can observe the forest as the birds see it, walk "within" the forest canopy, and appreciate the explosion of plant epiphytes and miniature orchids that cover every tree branch and display a dazzling multiplicity of forms. Monkeys, margays (*Leopardus wiedii*), and gray foxes (*Urocyon cinereoargenteus*) also rely on the bridges, using them to extend their range and travel more quickly from one feeding place to another.

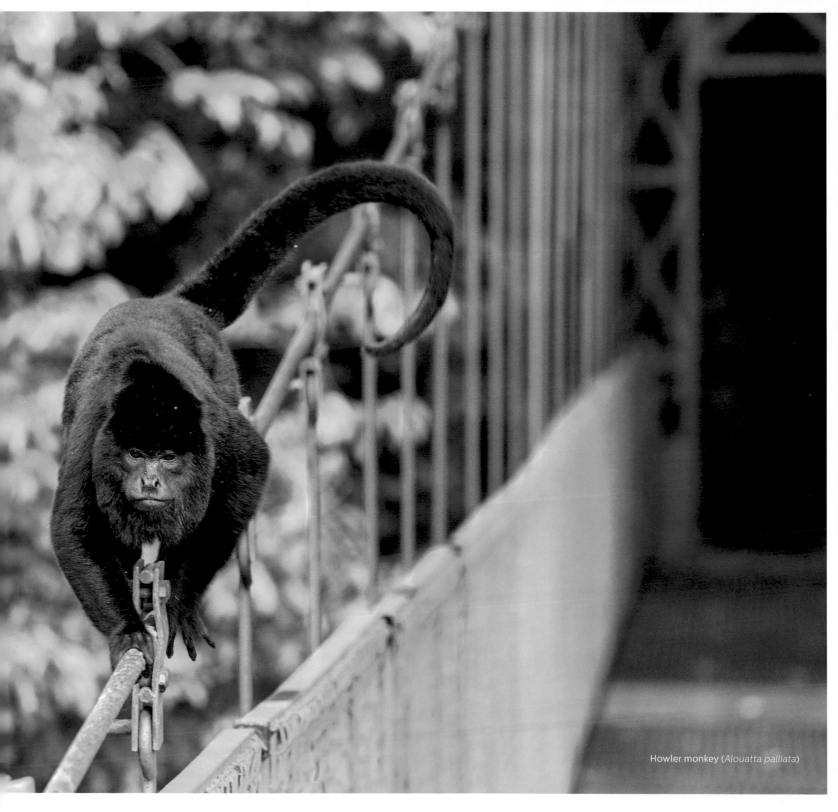

Howler monkey (*Alouatta palliata*)

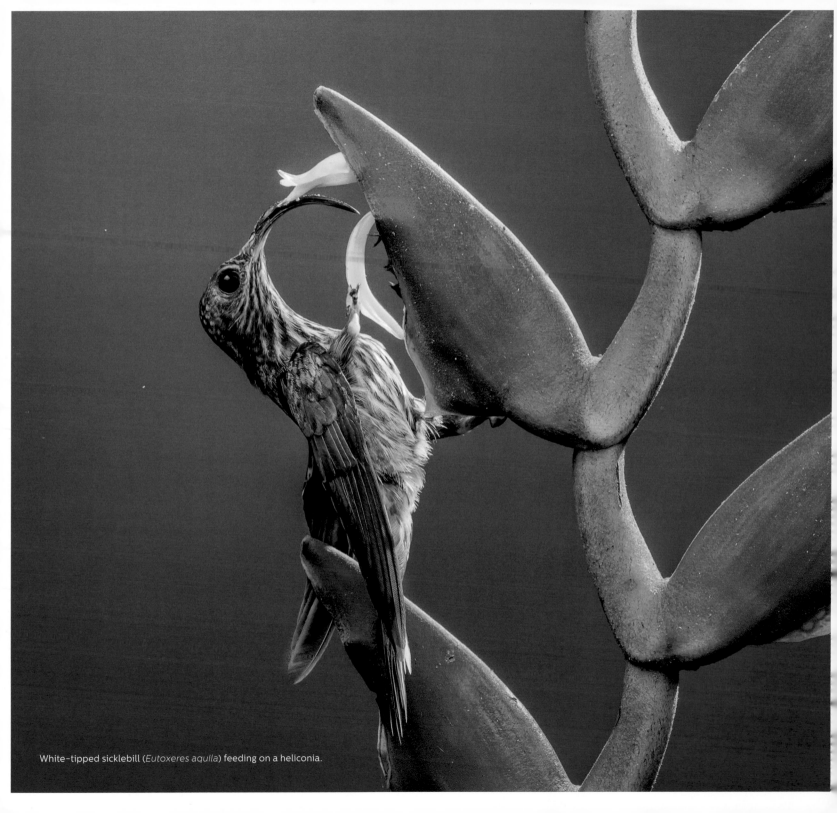
White-tipped sicklebill (*Eutoxeres aquila*) feeding on a heliconia.

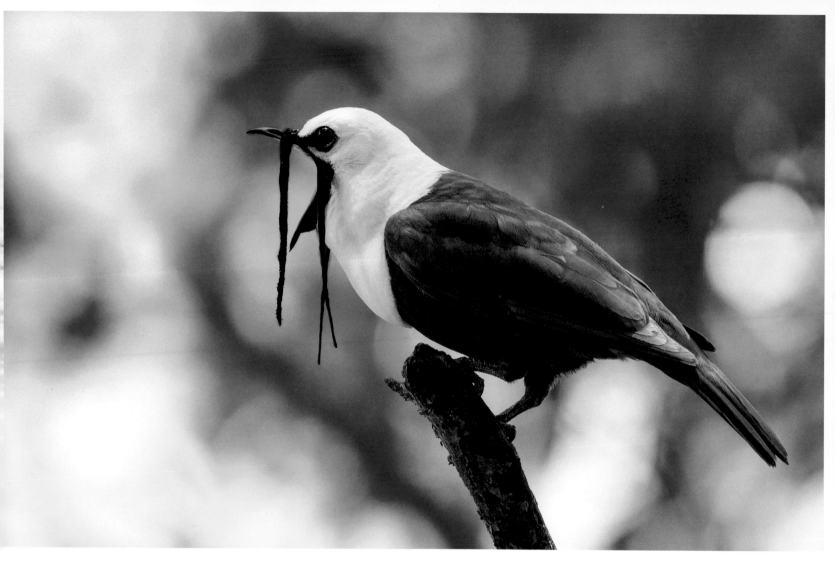

In Monteverde, the three-wattled bellbird (*Procnias tricarunculatus*) delivers its resonant call from April to August, when it reproduces. Once the chicks have grown up a bit, this species begins one of the longest and most circuitous migrations of any bird in the country. In September, it descends to 2625 feet (800 m), then spreads out to the coastal regions of the Gulf of Nicoya. The longest leg of the journey begins in December, when the bellbirds traverse the country and head north to Tortuguero and the Indio Maíz Reserve in Nicaragua. They will remain there until April, when they return to Monteverde.

GOD OF
THE SKIES

The resplendent quetzal (*Pharomachrus mocinno*), whom the Maya called "the God of the skies," performs altitudinal migrations, like the bellbird. From February to May, it nests and rears its chicks in Monteverde and then descends to lower elevations, in search of its main source of food, fruiting *aguacatillo* ("little avocados"). Although they mainly eat fruit, when the quetzals feed their young, they also prey on lizards, frogs, insects, and other forms of protein, all of which will speed up the growth of the chicks.

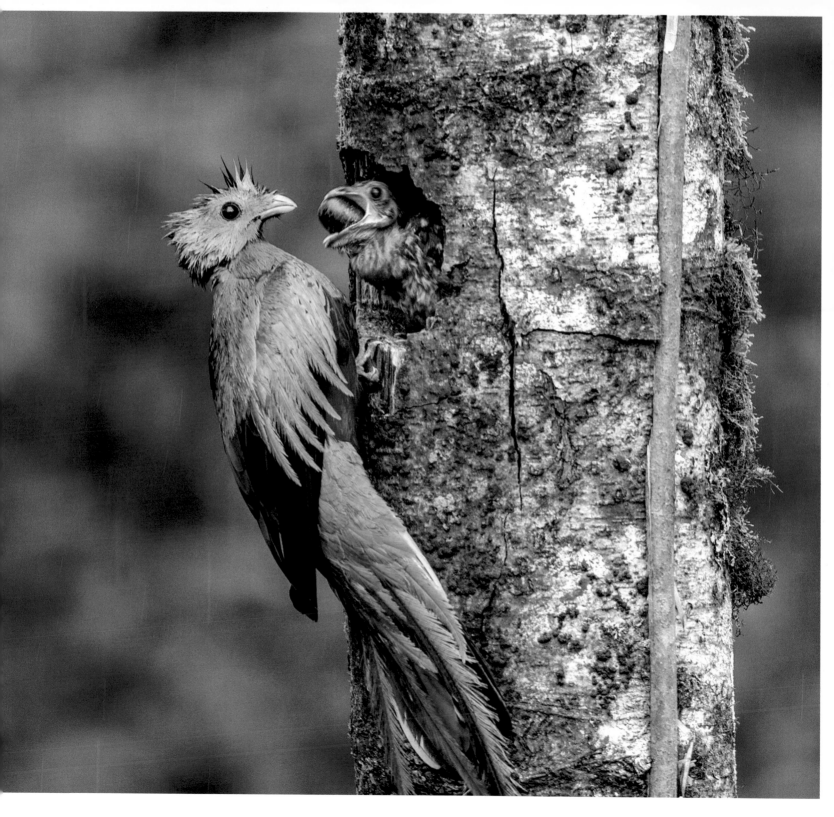

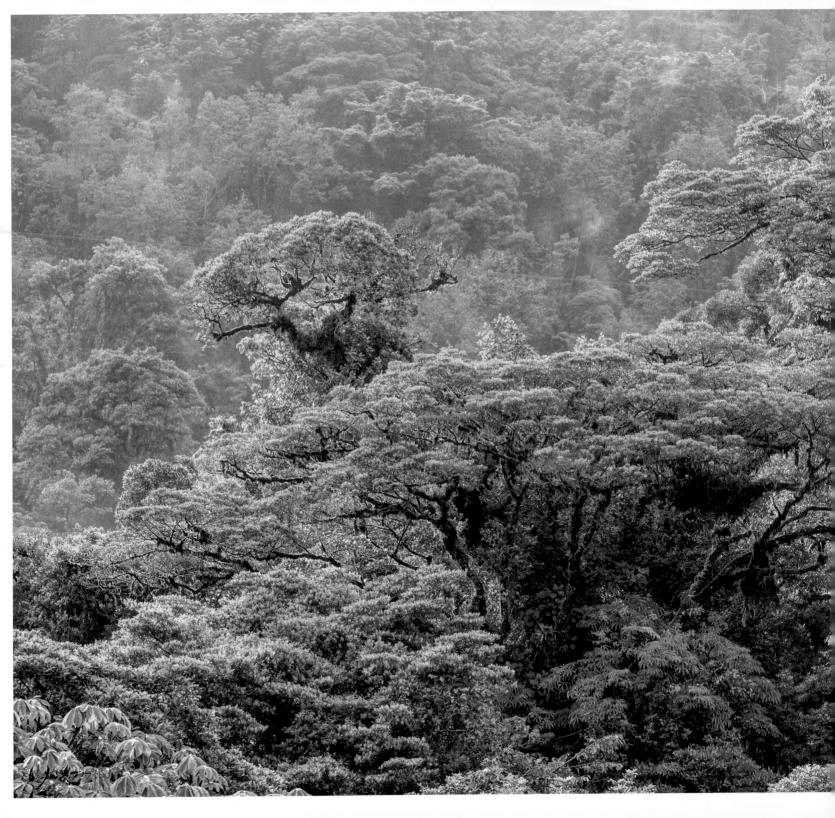

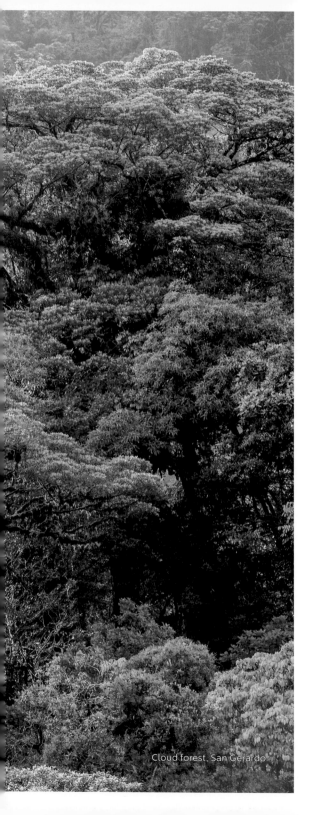

Cloud forest, San Gerardo

FORESTS SHAPED BY SUNLIGHT

Light is the architect of the cloud forest. Plants compete with each other, after all, to reach the sun and in the process shape the structure and composition of the forest. But even in the upper reaches of the canopy, plants only receive 75% of the sunlight, because the mists and dew that characterize the cloud forest filter out some of the light; and young plants on the forest floor receive a mere 0.5% of the sunlight from above. The abundance of epiphytes is a direct consequence of this, since their seeds are disseminated by birds in the upper canopy and consequently receive more sunlight.

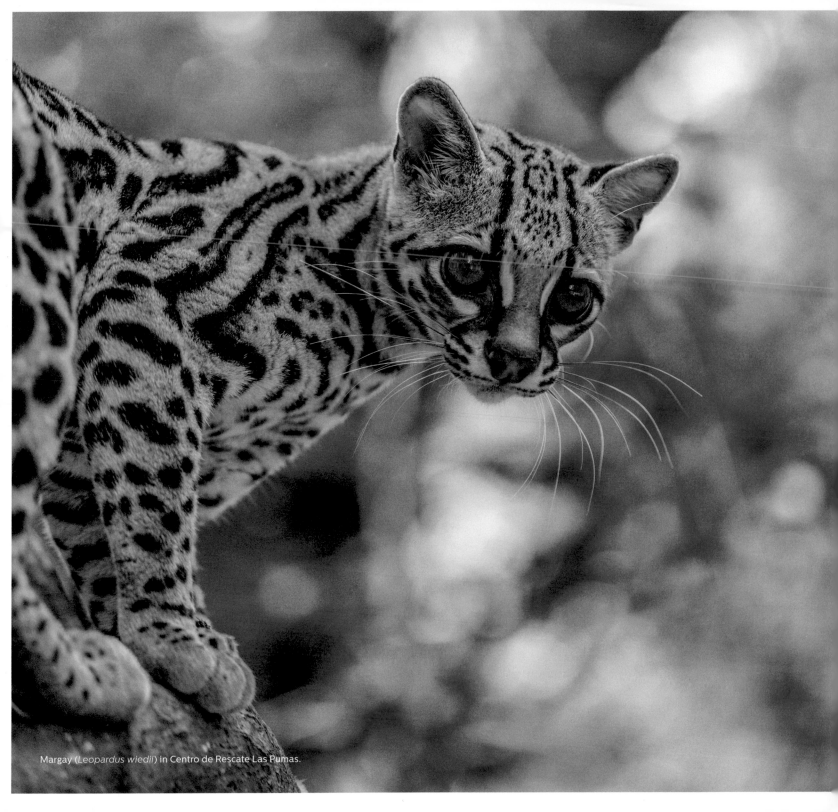

Margay (*Leopardus wiedii*) in Centro de Rescate Las Pumas.

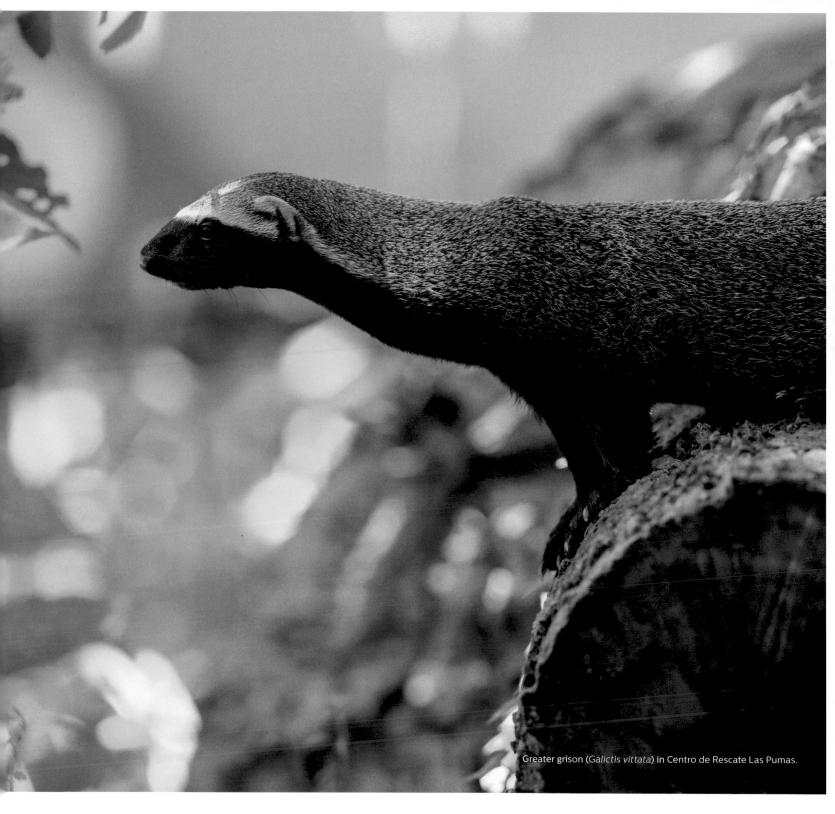

Greater grison (*Galictis vittata*) in Centro de Rescate Las Pumas.

Quebrada Sucia, Santa Elena

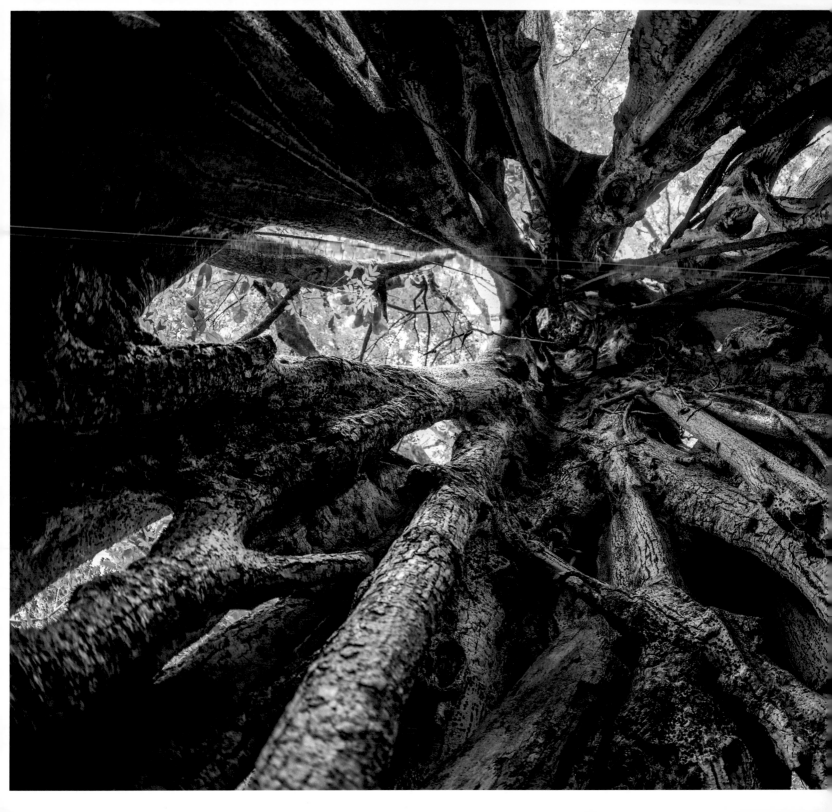

STRANGLING
ROOTS

The delirious interlocking structures of fig trees (family Moraceae) result in part from how they are propagated. The sticky seeds of the fig tree are deposited in the forest canopy, on trees of other species. They start out as epiphytes and begin to grow toward the forest floor, where they take root. Eventually these roots "strangle" the support tree, which dies. When the host tree rots away it leaves an empty cavity in the center of the fig tree roots. This cavity will become home to owls and bats and other small mammals.

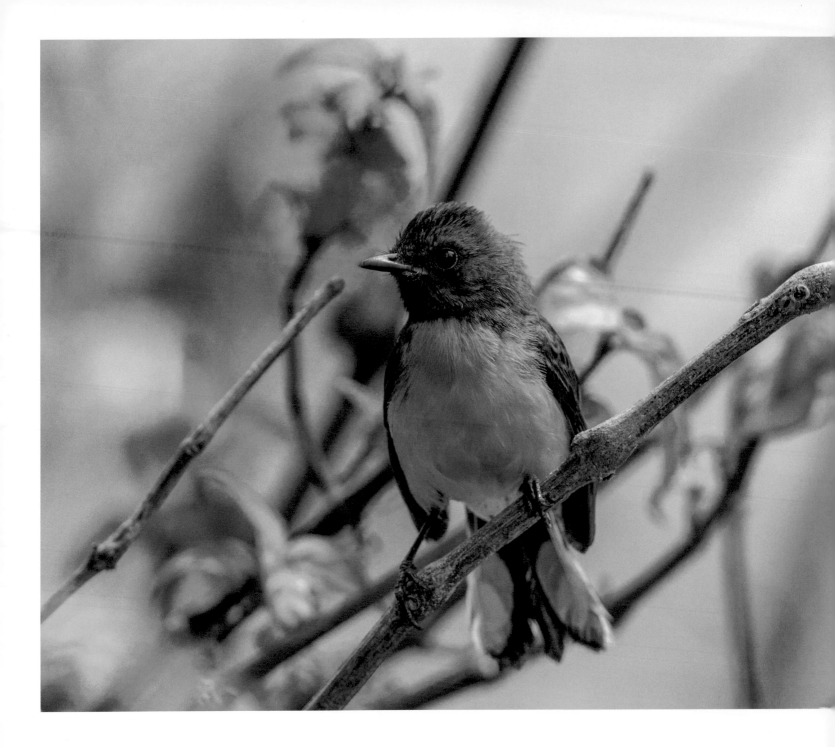

In Monteverde it is possible to observe 450 species of bird, almost half of all species registered for the country!

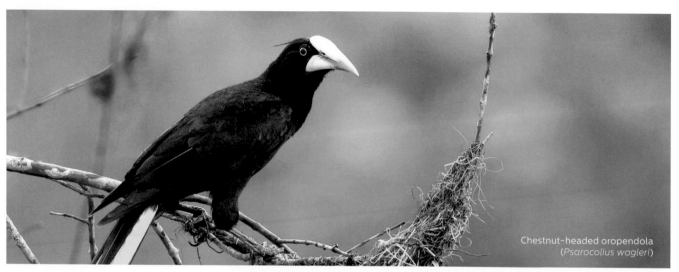

Chestnut-headed oropendola (*Psarocolius wagleri*)

Slate-throated redstart (*Myioborus miniatus*)

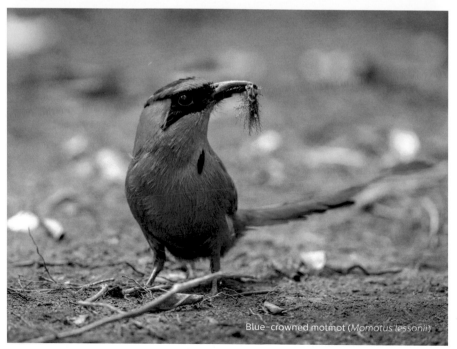

Blue-crowned motmot (*Momotus lessonii*)

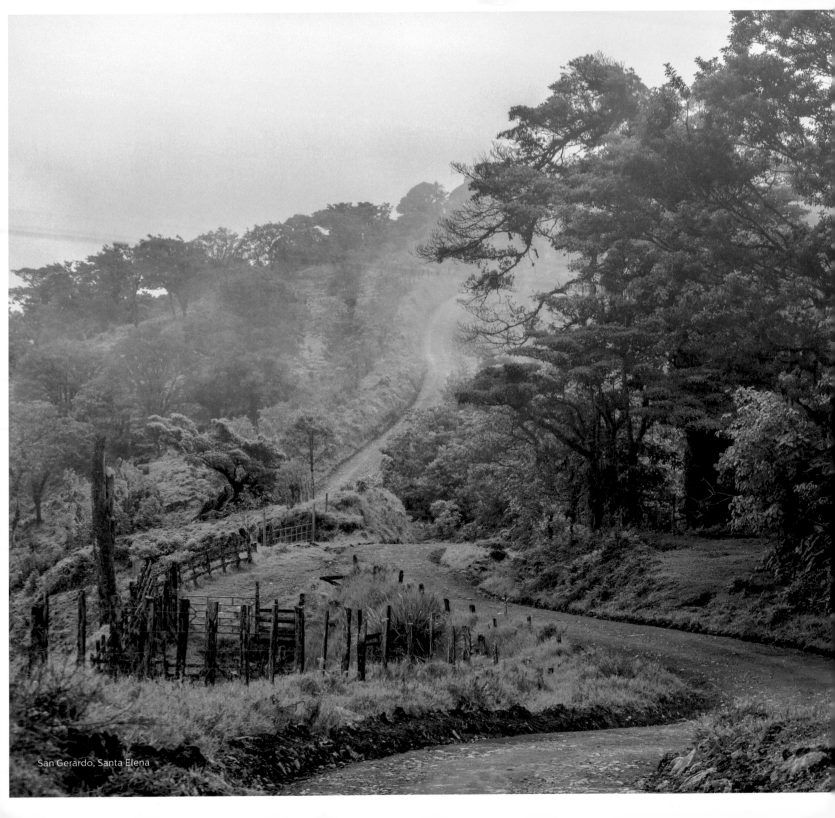

San Gerardo, Santa Elena

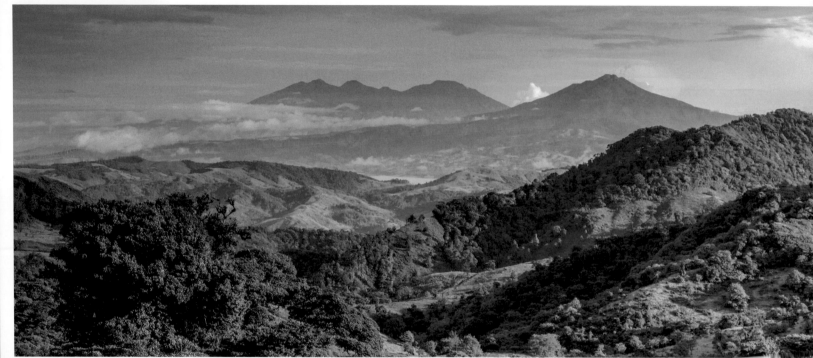

The Tilarán Mountain Range forms part of the Continental Divide, which runs from northern Alaska to Tierra del Fuego. The water that falls on it is funneled either to the Pacific Ocean or, to the east, the Caribbean Sea and Atlantic Ocean, molding two universes completely different in their culture, biology, and climate.

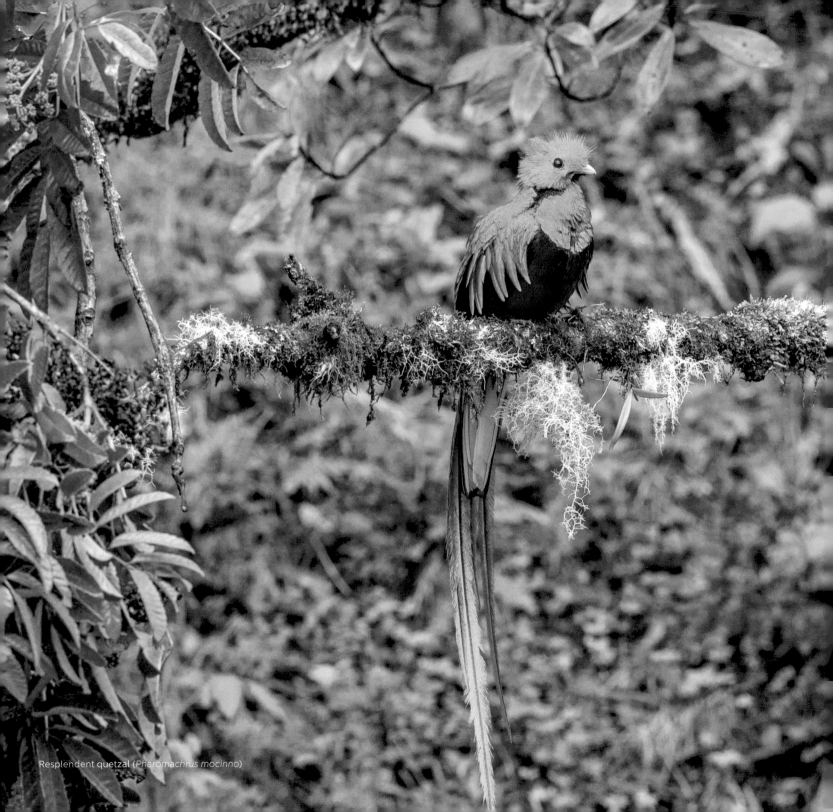

Resplendent quetzal (*Pharomachrus mocinno*)

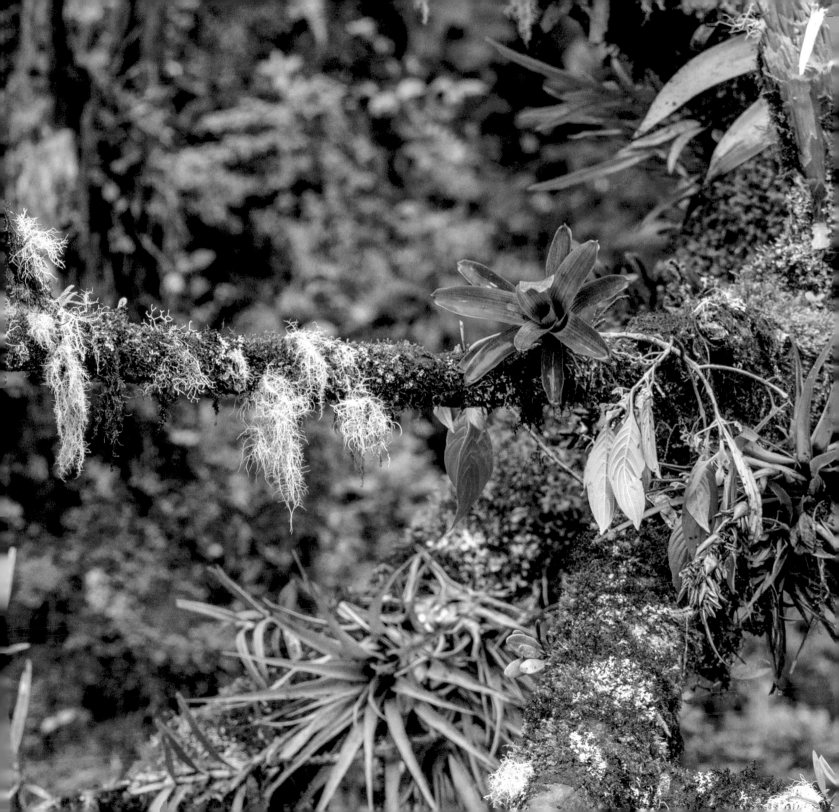

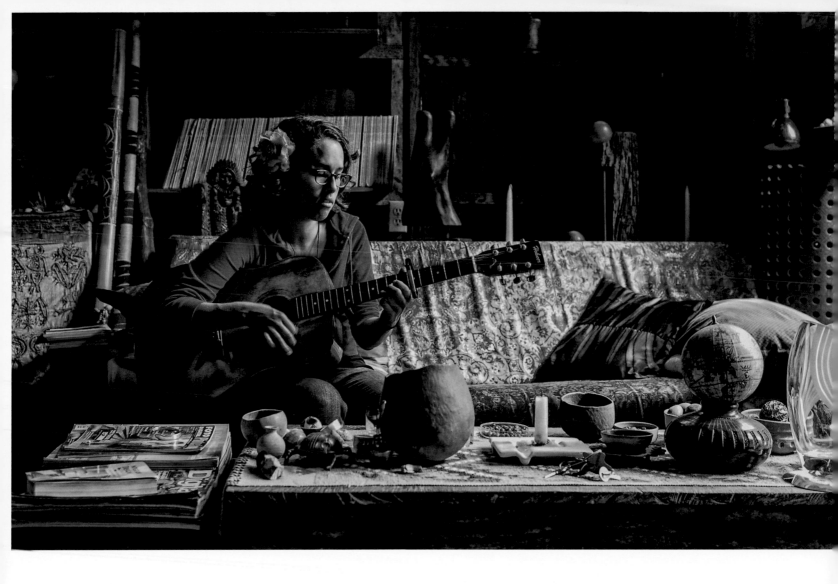

For such a small community, Monteverde hosts a surprising number of artists, scientists, and photographers. Attracted by the charms of the cloud forest and the tradition of tolerance that has always distinguished the community, violin makers, dancers, potters, painters, sculptors, musicians, nature photographers, and some of the most renowned scientists of the region have made their home here.

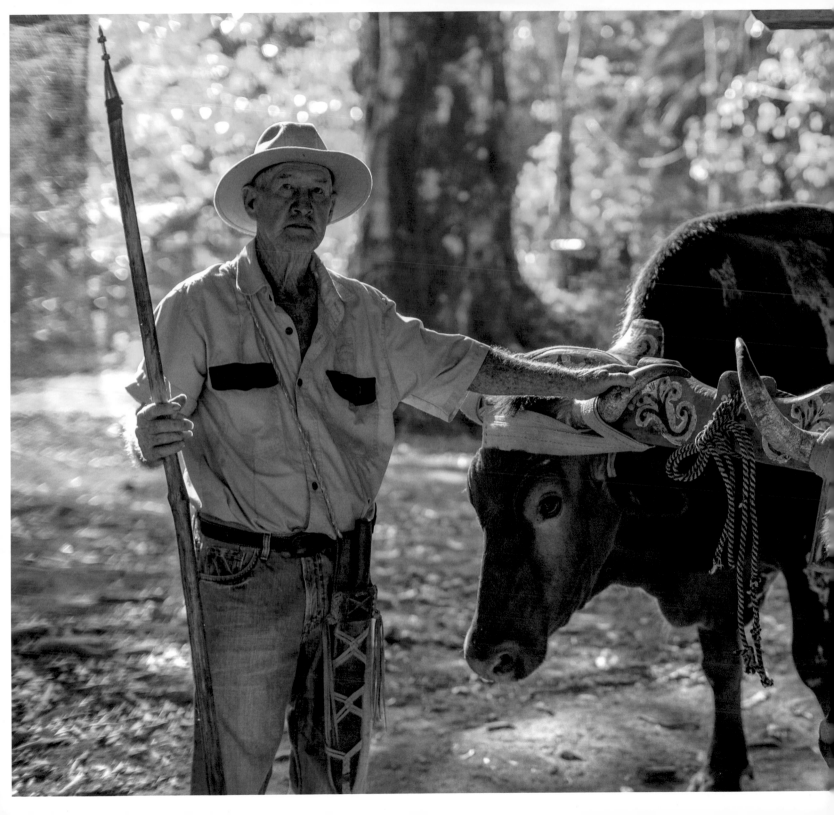

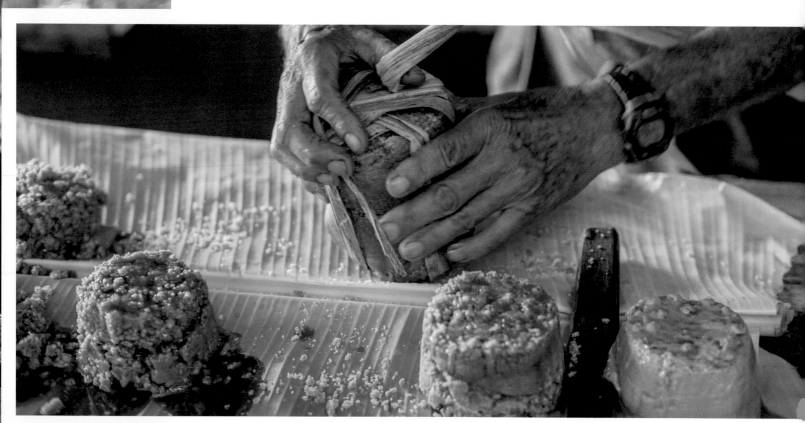

Originally from New Guinea, sugar cane was one of the first crops introduced to the New World by the Spaniards. Brought by Christopher Columbus on his second trip, the cultivation of the plant quickly spread throughout the continent, and sugar became one of the main export products of the colonies. In Costa Rica, every town once had one or more *trapiches*, small artisanal wooden presses that extract juice from the cane. Their number diminished with the advance of industrial production and an appetite for refined sugar. Nowadays, the remaining *trapiches* serve mainly as tourist attractions or to produce the traditional *tapa dulce*, concentrated blocks of brown sugar.

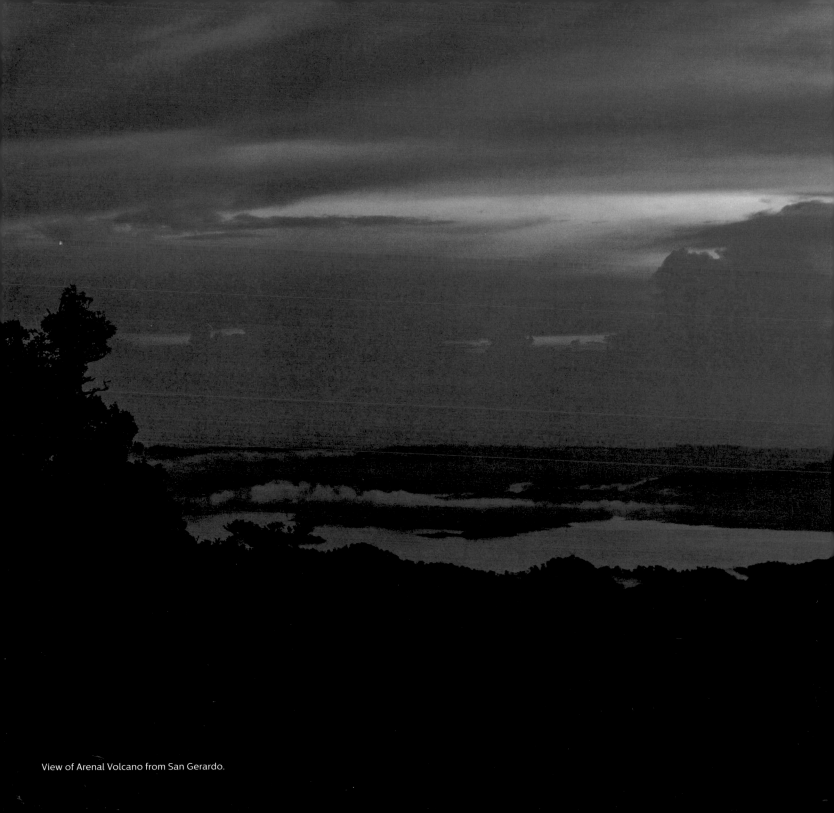

View of Arenal Volcano from San Gerardo.

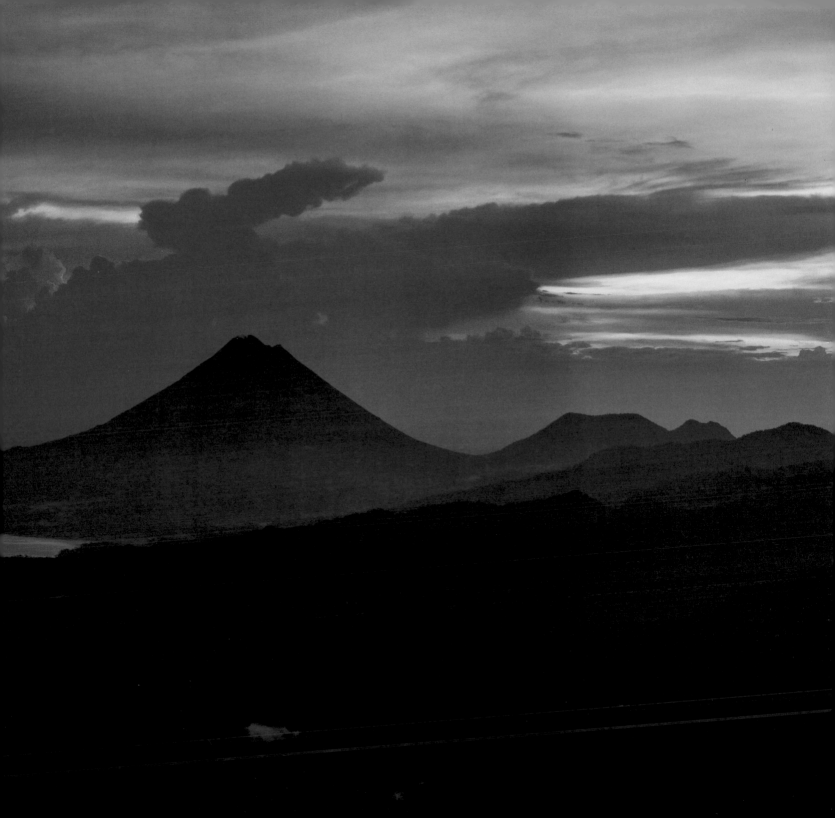

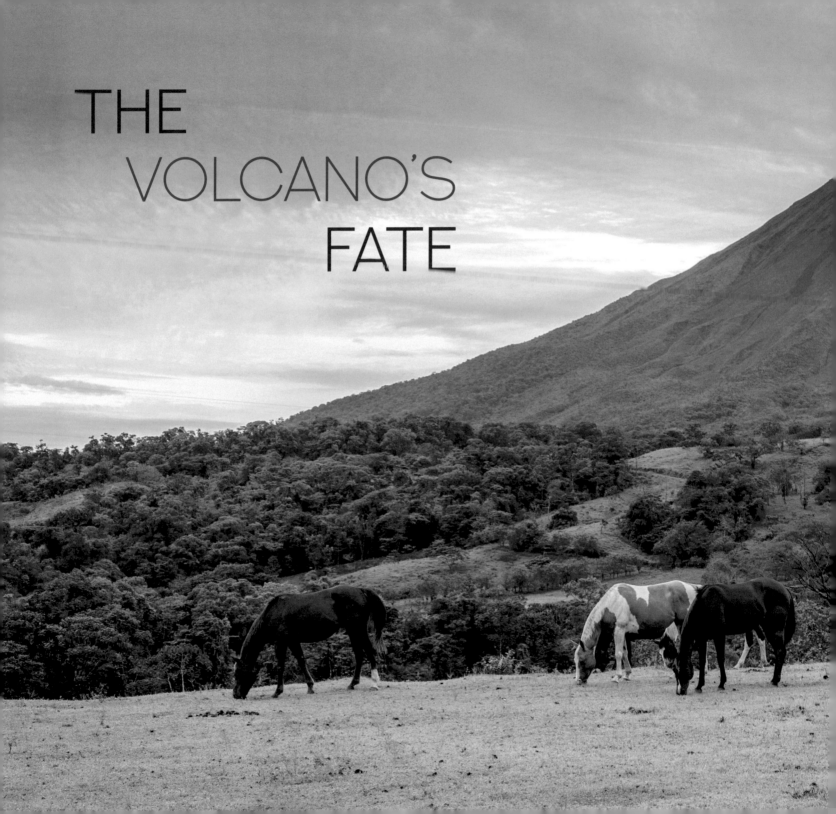

THE VOLCANO'S FATE

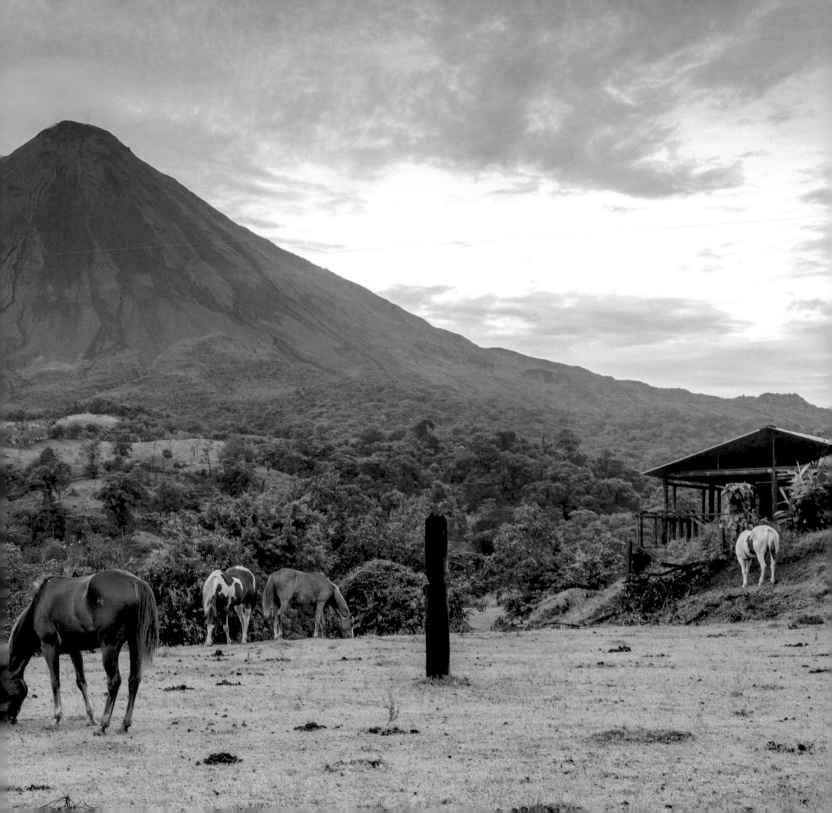

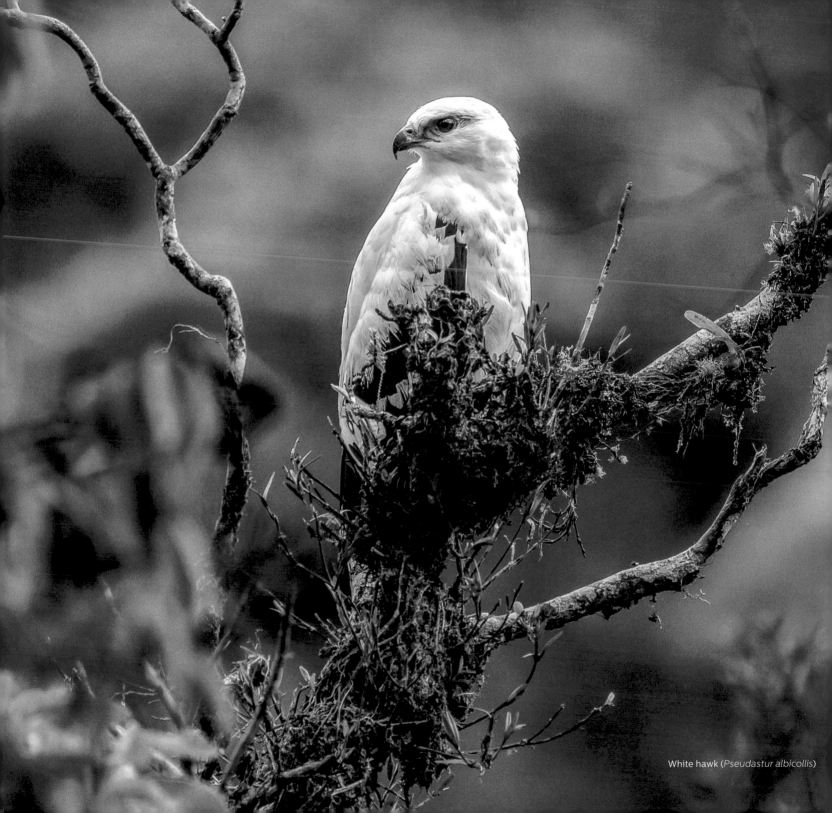

White hawk (*Pseudastur albicollis*)

To the west of the mountain chain that runs through the center of the country, a series of volcanic peaks "descends" toward the Caribbean coast, surrounded by a landscape that has been sculpted for thousands of years by rivers, wetlands, waterfalls, springs, and lakes.

Here lie fertile plains used for agriculture and wetlands that are permanently swept by trade winds from the Caribbean and nourished by minerals that trickle down from the tall volcanic peaks.

This region, which stands under the gaze of Arenal Volcano, was among the first in the country to be inhabited by hunter tribes, who arrived between 12,000 and 8000 BC. One clue to their presence is a 10,000-year-old obsidian spearhead found in the Lake Arenal area.

The volcanoes supply the region with hypnotic hot springs, pools of boiling mud, and igneous rocks. Many of these rocks bear petroglyphs and other inscriptions by which ancient cultures portrayed natural disasters, shamanic rituals, and human sacrifices.

Subject to the hegemony of the Huetar kings, the Botos, the principal inhabitants of the area, were Rama indigenous peoples of Chibchan lineage who established their territory on the banks of the San Juan River and nearby plains more than 2000 years ago.

The dense vegetation and lack of passable roads in this region dissuaded the Spanish colonists from attempting to subjugate it. As a result, the area became a refuge for rebellious slaves and those who, for whatever reason and whether black, indigenous, or white, fled the colonial yoke.

Since the late 19th century, farmers had grown beans, tubers, corn, and cacao on these swampy plains. In the 1930s, when the first modern human settlements and cattle ranches appeared in La Fortuna, deforestation began to accelerate. At that time traveling the 45 miles (70 km) between La Fortuna and the Central Valley was a two-week trip by oxcart, so the area continued to remain relatively isolated from the rest of the country.

The eruption in 1963 of Irazú Volcano, which covered the pastures of the Central Valley with ash for nearly two years, forced many cattle ranchers to move to the northern plains, where land was fertile and, most importantly, cheap. This was how La Fortuna and the surrounding plains became repopulated after centuries of abandonment. Most of these were small and medium-sized farms that combined subsistence agriculture with cattle ranching to produce meat for the Central Valley market.

A second catastrophe was even more unexpected, as nobody could have imagined that what had been considered a mere mountain for centuries might pose a threat. For 530 years, Arenal Volcano had been asleep, but when it awoke, on the morning of July 29th, 1968, it destroyed two towns and buried nearly one hundred people. Over time, the violent expulsion of lava, ash, and fiery clouds, which would reoccur intermittently until 2010, would begin to be seen as less of a threat than an opportunity, a dazzling fireworks display that would attract tourists from around the world.

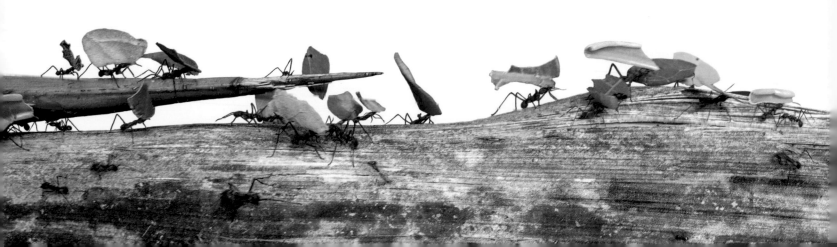

Tourism began to take off in the early 1980s with the inauguration of the first paved road in 1982. The tourists, the majority of whom initially were *ticos*, came not just to see the volcanic fireworks but also Arenal dam. This public project, Herculean in scope, has been operated by the Costa Rican Institute of Electricity (ICE) since 1977. Created to supply electricity to the country, the flooding caused by the dam submerged two towns and created the largest body of fresh water in Costa Rica, with a size of 34 square miles (87 km²).

This series of catastrophes and coincidences made Arenal different from other tourist destinations in the country. The group of small- and medium-scale farmers that had settled in the region to escape the Irazú Volcano eruption chose to develop the tourist attractions themselves instead of selling their land to foreigners or large tourism companies, creating hanging bridges in the jungle, hot spring resorts, and adventure centers offering rappelling down waterfalls, rafting, and dozens of other activities involving the water that flows down from the mountains of Monteverde.

While Arenal perhaps lacks the mystique of Monteverde, it does offer a variety of adrenaline-charged activities. As different as these two communities are, however, they are linked together in several ways. Both are among the safest, most peaceful towns in the country, a product of their united and organized communities. And, the waters from the cloud forest in Monteverde feed the rivers and lakes that sustain tourist attractions in Arenal. But, above all, they share the Children's Eternal

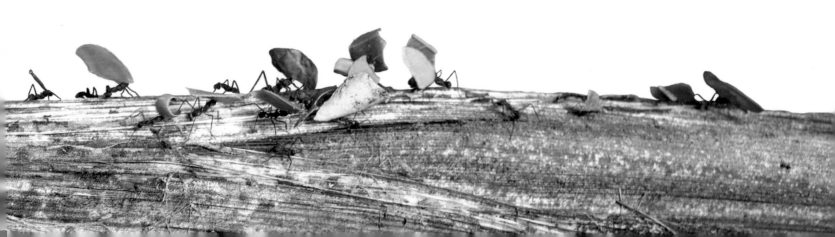

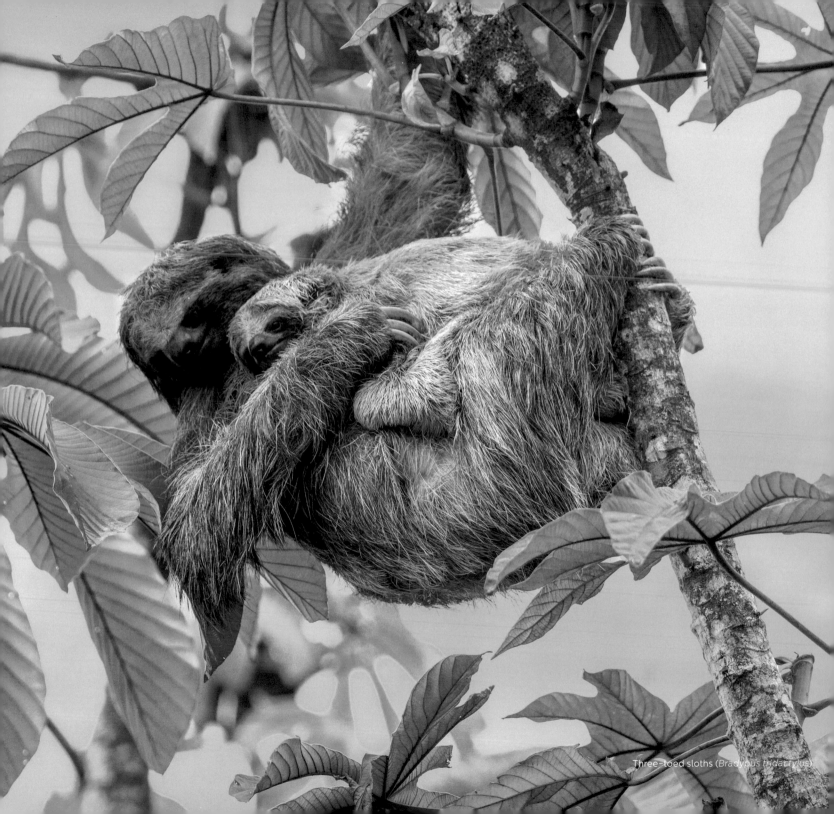

Three-toed sloths (*Bradypus tridactylus*)

Forest, which connects the Monteverde Cloud Forest Biological Reserve with Arenal Volcano National Park and the Alberto Manuel Brenes Biological Reserve, forming a continuous block of forest of about 150,000 acres (61,000 hectares).

The two roads that connect the communities are as different as the communities themselves. On the northern side of the lake is the road traveled by tourists. It is well-paved and lined with small hotels and restaurants with lake views; along it, you come to Nuevo Arenal, one of the small towns rebuilt in the 1970s to accommodate the settlers that the dam had left without homes.

On the southern side, a dirt road traverses the least populated lands in this region. Initially, it borders the lake until, after crossing the Caño Negro River—which is safe to do only during the dry season—it delves into the dense jungle for several miles, crossing rivers, wetlands, pastures, and clusters of houses until it passes near the former location of Tronadora, one of two towns that was submerged by the lake. Both roads converge in Tilarán, where the road that connects Arenal and Monteverde begins.

However, the most spectacular path for those who want to go deep into the cloud forest and discover its mysteries is undoubtedly the Tapir Trail. Blazed with a machete by Wilford "Wolf" Guindon, one of the Quaker founders of Monteverde, it took 15 years to complete this trail, after many failed attempts.

It is a 17-mile (28-km) route from the entrance of the Monteverde Cloud Forest Biological Reserve, on the Pacific slope, to the Arenal Observatory Lodge, close to La Fortuna; conquering it requires two or three days of hiking. In Wolf's words, "just go along the ridge and look for those land bridges that the animals use to get from one set of hills to the next. Before you know it you'll be at the foot of the volcano, so long as you don't wander off the trail and onto the wrong ridge."

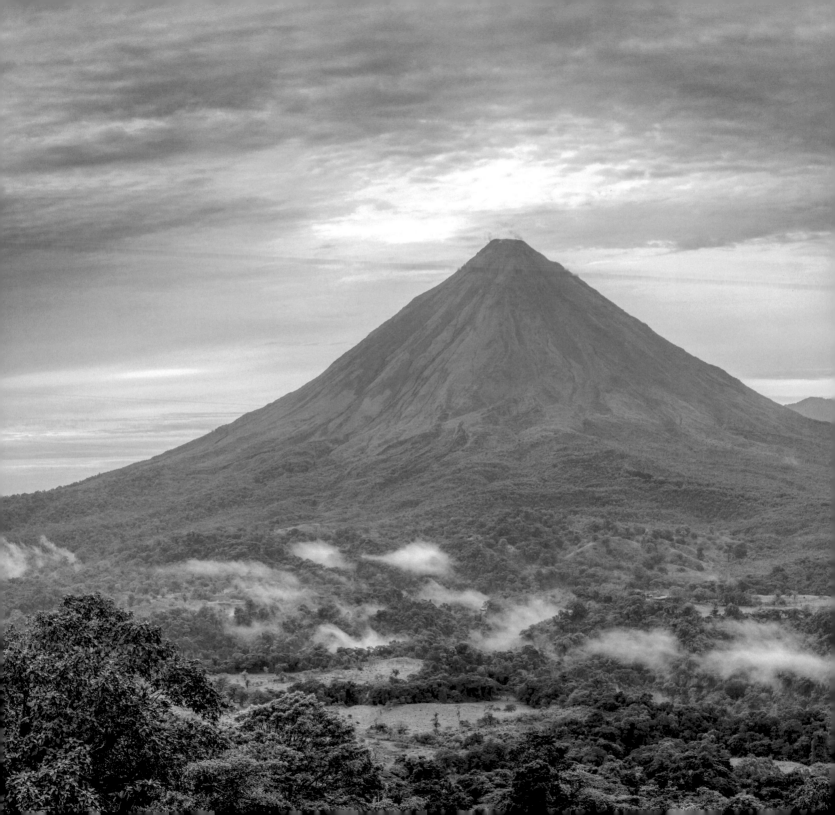

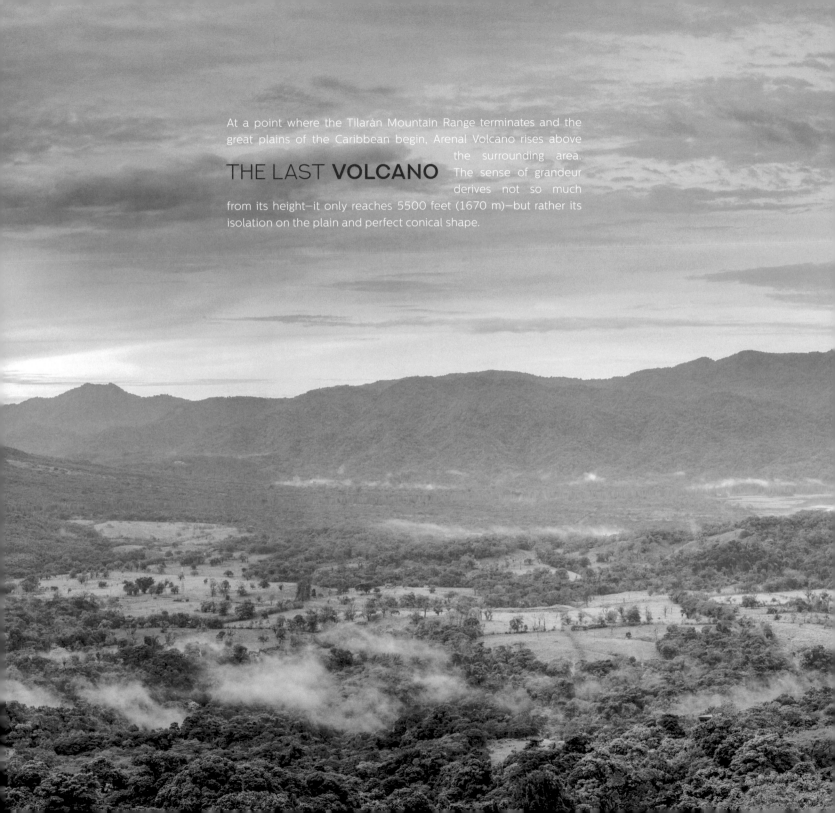

At a point where the Tilarán Mountain Range terminates and the great plains of the Caribbean begin, Arenal Volcano rises above the surrounding area.

THE LAST **VOLCANO**

The sense of grandeur derives not so much from its height—it only reaches 5500 feet (1670 m)—but rather its isolation on the plain and perfect conical shape.

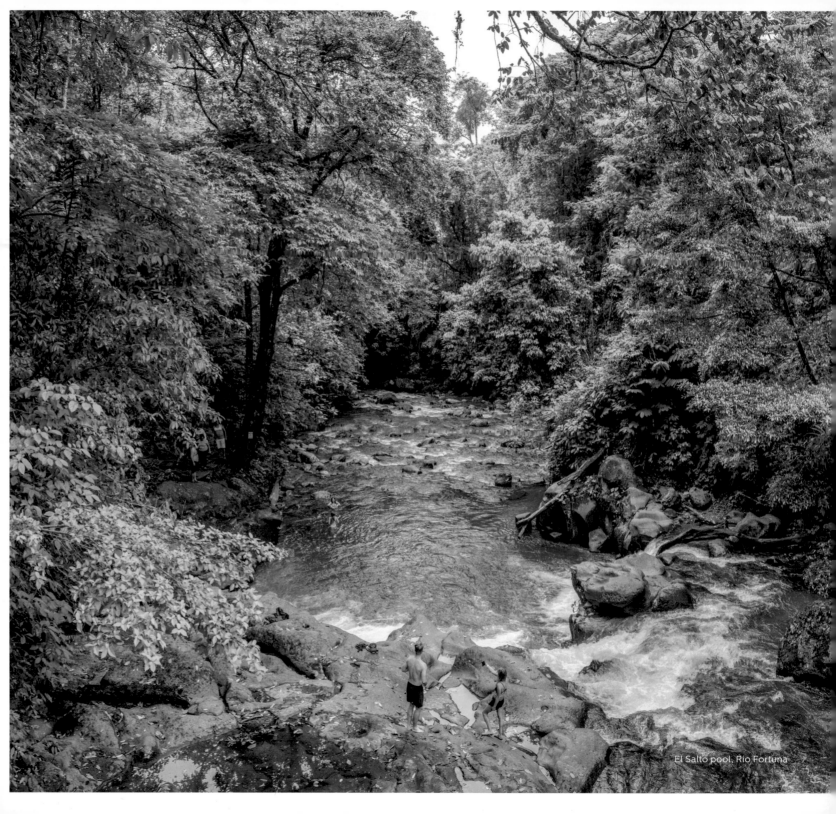

El Salto pool, Rio Fortuna

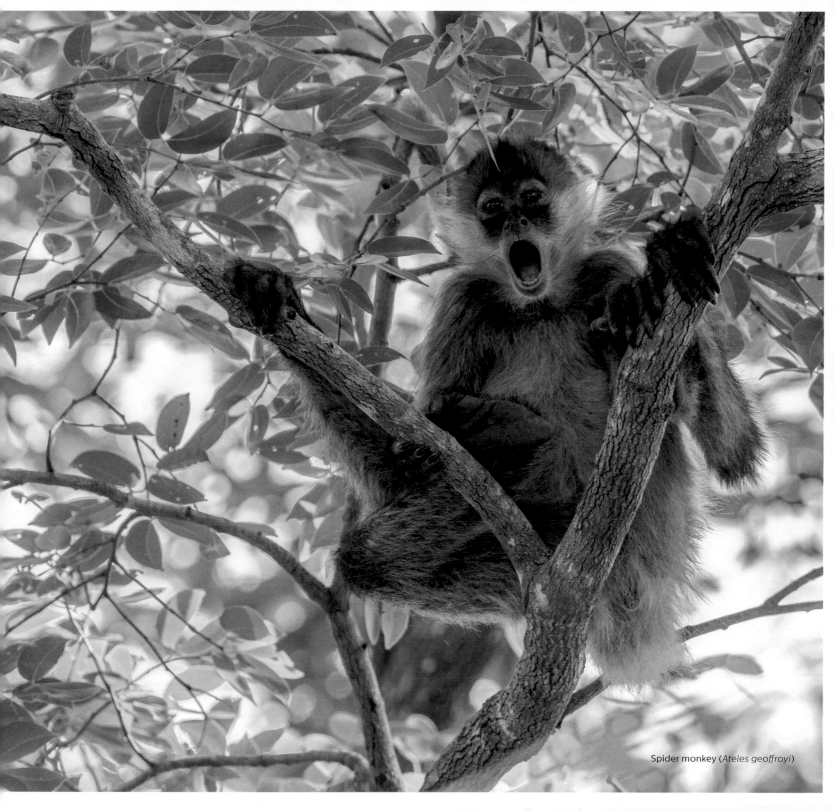
Spider monkey (*Ateles geoffroyi*)

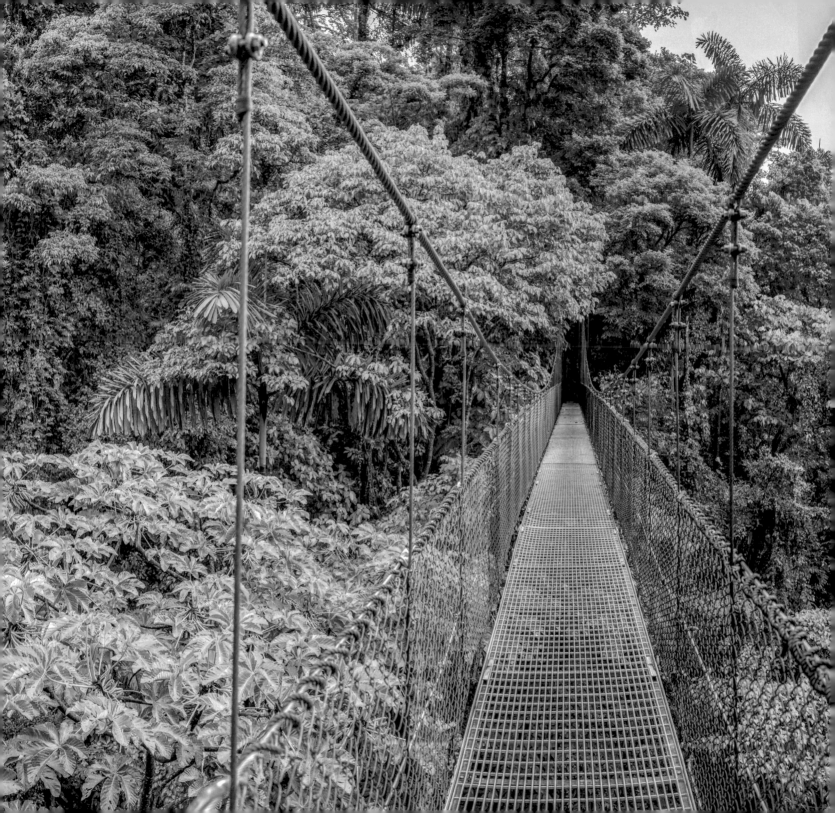

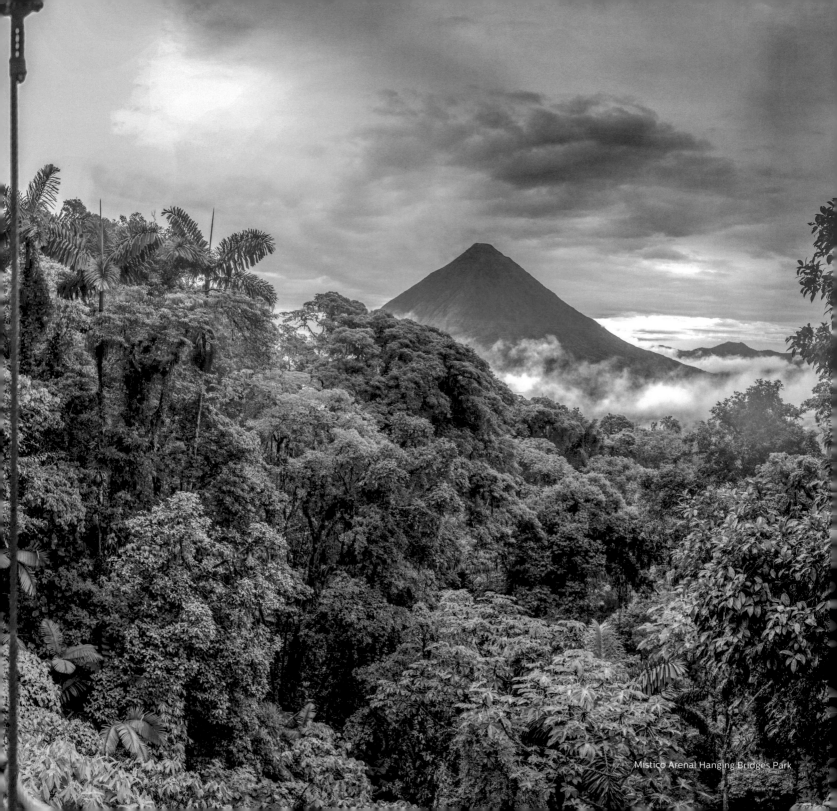

Mistico Arenal Hanging Bridges Park

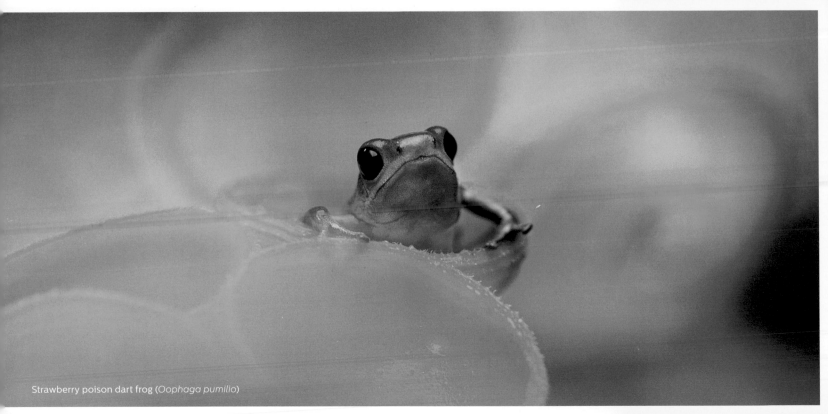
Strawberry poison dart frog (*Oophaga pumilio*)

The strawberry poison dart frog is, for now, the only animal known to feed its young to provide them with chemical defenses. At birth the tadpoles are not poisonous and are therefore vulnerable to predators. The female feeds the juveniles infertile eggs, gradually supplying them with the toxins that will protect them as adults. Where do her toxins come from? In part from eating tiny ants that contain alkaloids.

54

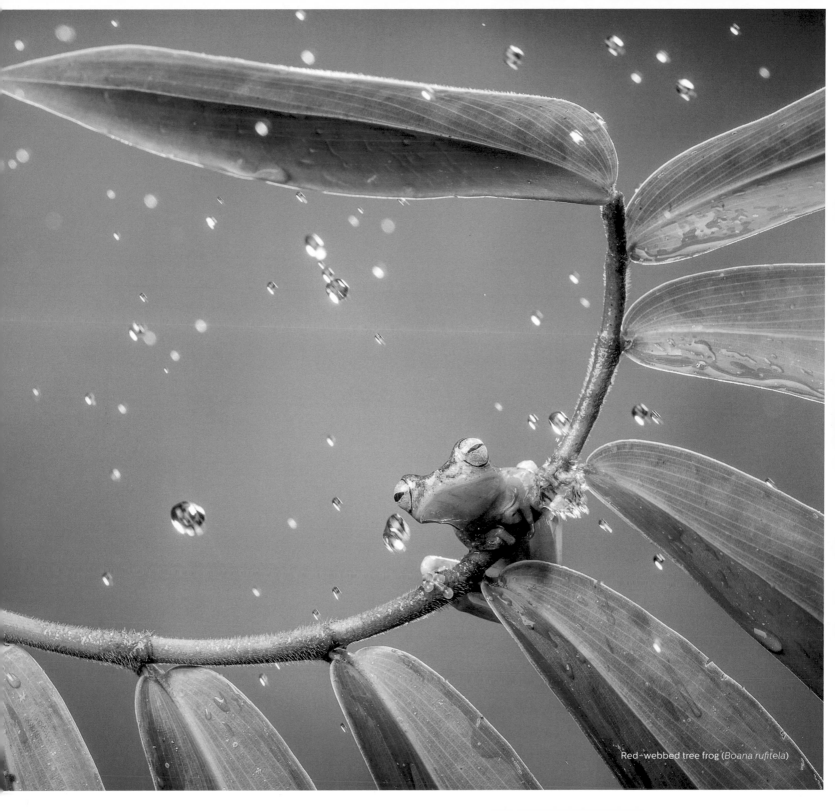

Red-webbed tree frog (*Boana rufitela*)

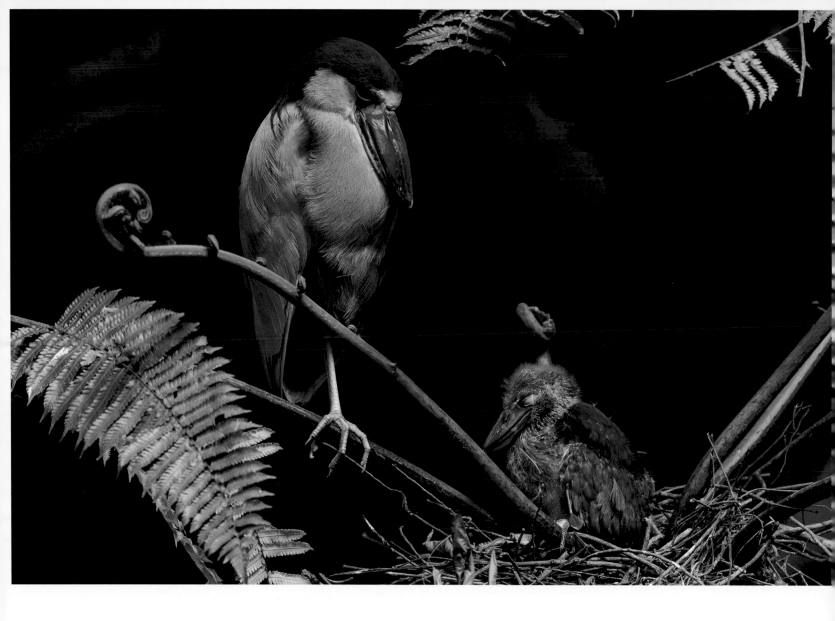

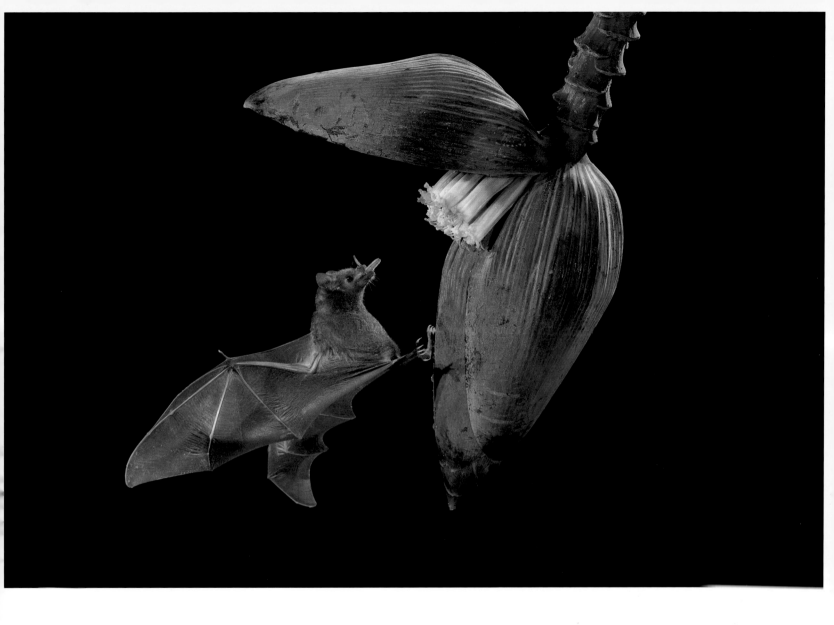

Most mammals, amphibians, and several species of bird are nocturnal. The boat-billed heron (*Cochlearius cochlearius*), for example, spends its days sleeping in groups of up to 50 individuals, while at night it hunts alone. Bats, which are the only mammals able to fly, are also nocturnal and represent the most numerous groups of mammals present in Costa Rica with 114 species, more than 10% of all species known worldwide. Pictured here is a Palla's long-tongued bat (*Glossophaga soricina*), its most notable characteristic is its ability to remain suspended in air like a hummingbird while it feeds on nectar.

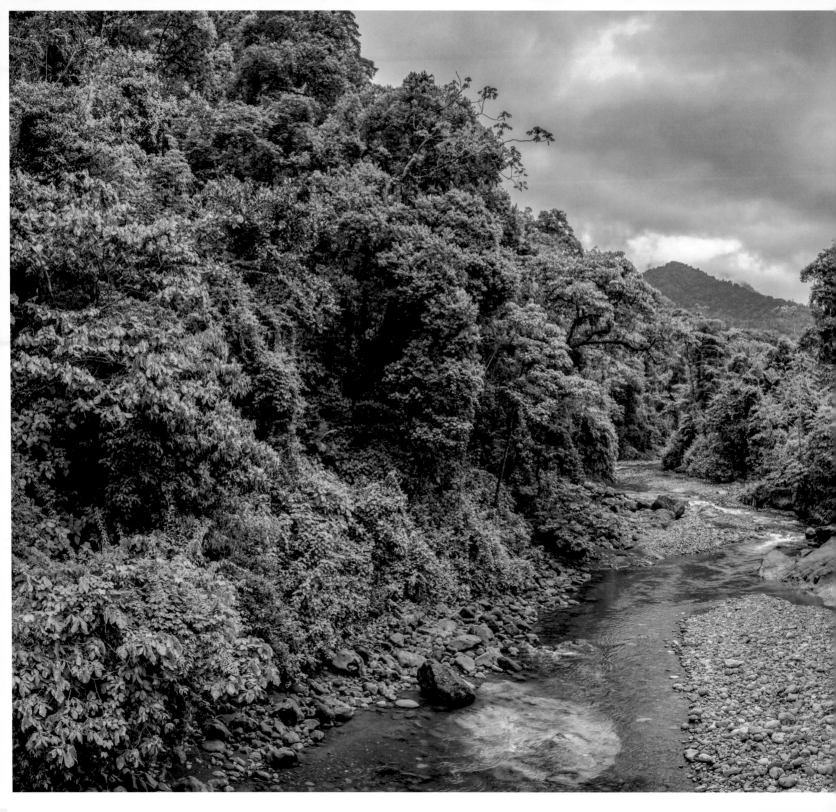

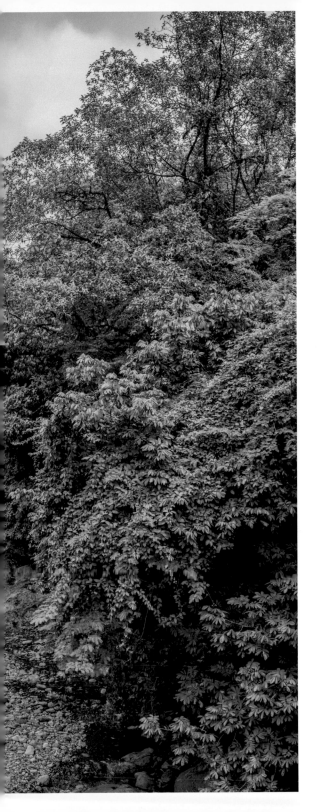

<div align="right">

PEÑAS

BLANCAS

</div>

In 1987, increasing rates of deforestation threatened the Peñas Blancas Valley. In response, the Monteverde Conservation League (MCL), with support from the World Wildlife Fund, organized a fundraising campaign that would make possible the addition of 13,100 acres (5300 hectares) of largely virgin forest to the Children's Eternal Forest. Today, the basin of the Peñas Blancas River, which descends from Monteverde to the plains surrounding Arenal Volcano, hosts one of two biological stations run by the MCL, that of Pocosol.

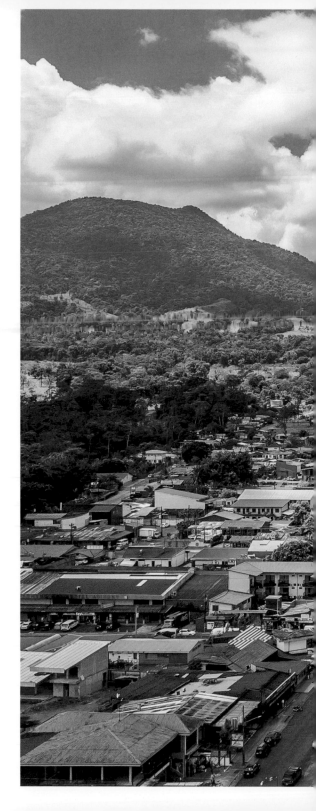

THE GUARDIAN OF
LA FORTUNA

In 1968 the eruption of Arenal Volcano devastated two villages and caused almost 200 deaths, but it did not affect the nearby town of La Fortuna, which lies to the east of the volcano. Indeed, while lava flows destroyed forest on the western slope of the volcano, forest on the eastern slope was left unscathed. This changed the fate of La Fortuna, which in little more than 30 years went from being a small agricultural center to one of the most prosperous tourist destinations in the country.

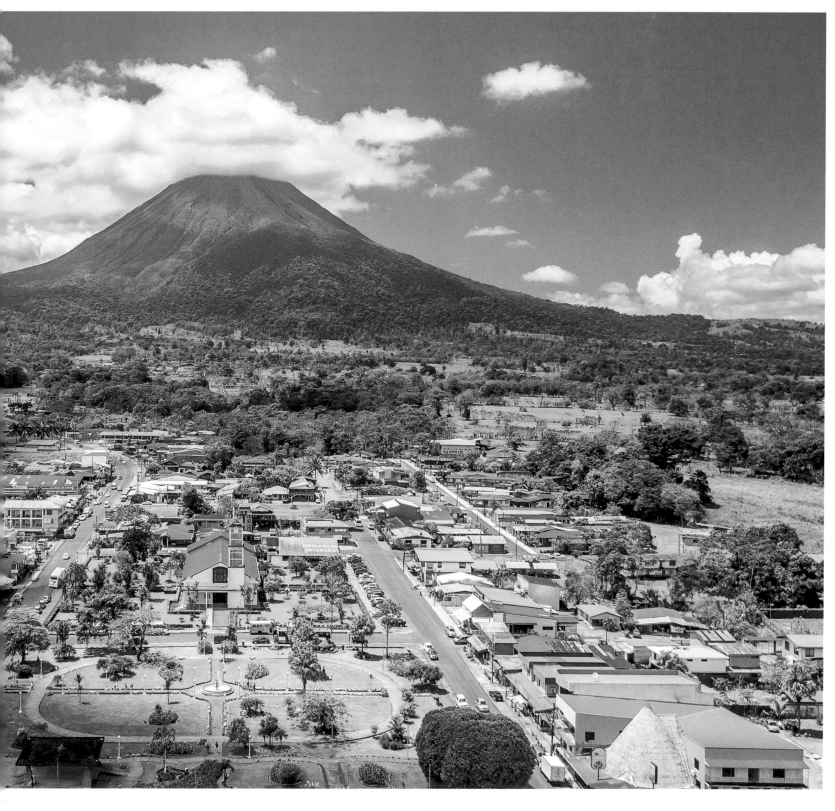

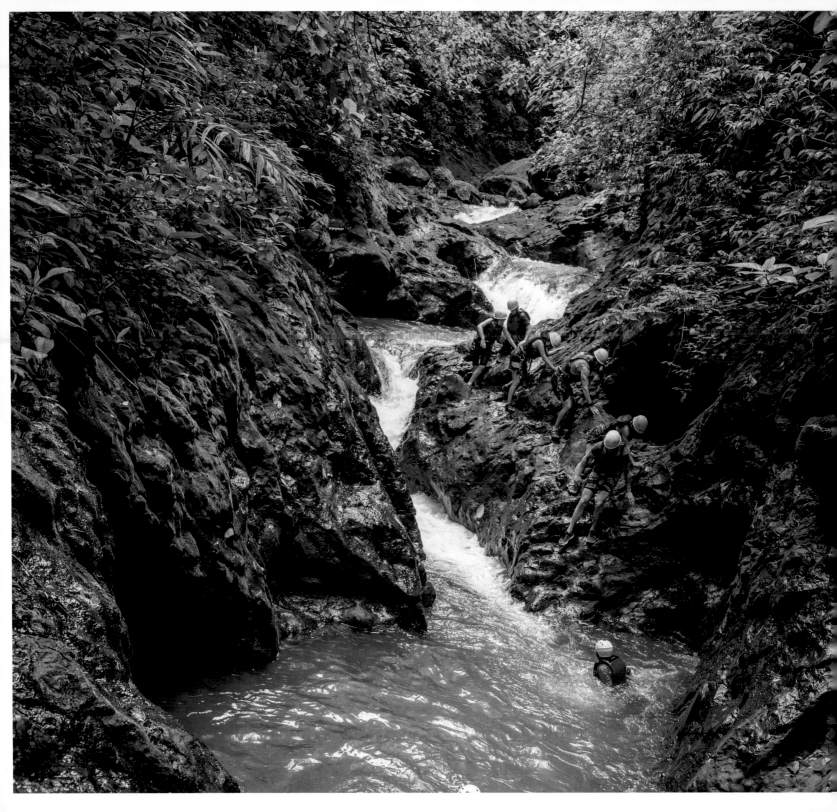

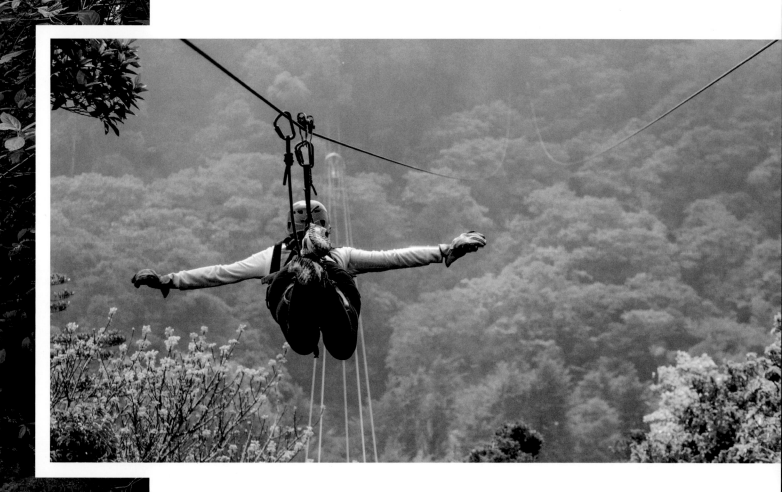

The Arenal area is the most popular adventure destination in Costa Rica. There are very few extreme sports that cannot be practiced here. You can trek along rivers, ride the second longest canopy cable in the country, raft down level 3 and 4 rivers, and kitesurf on one of the best sites in the world for that sport.

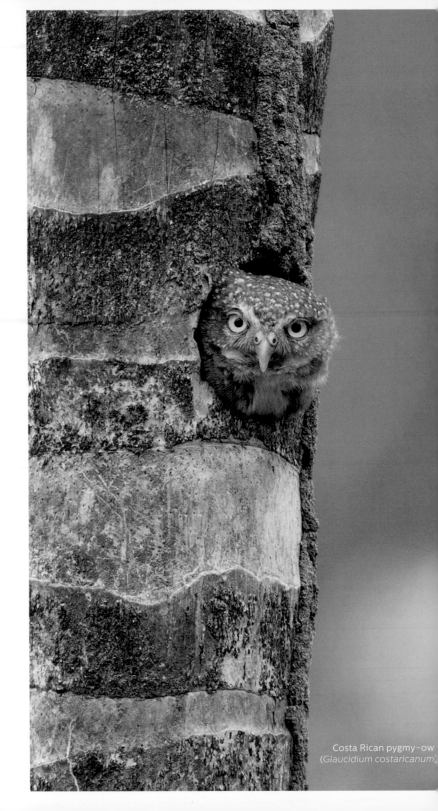

EYES IN THE
FOREST

In the forest, a vigilant gaze can make the difference between capturing prey or being eaten. With their eyes, predators and prey scour the surrounding terrain, attentive to any telltale movement.

Costa Rican pygmy-ow
(*Glaucidium costaricanum*)

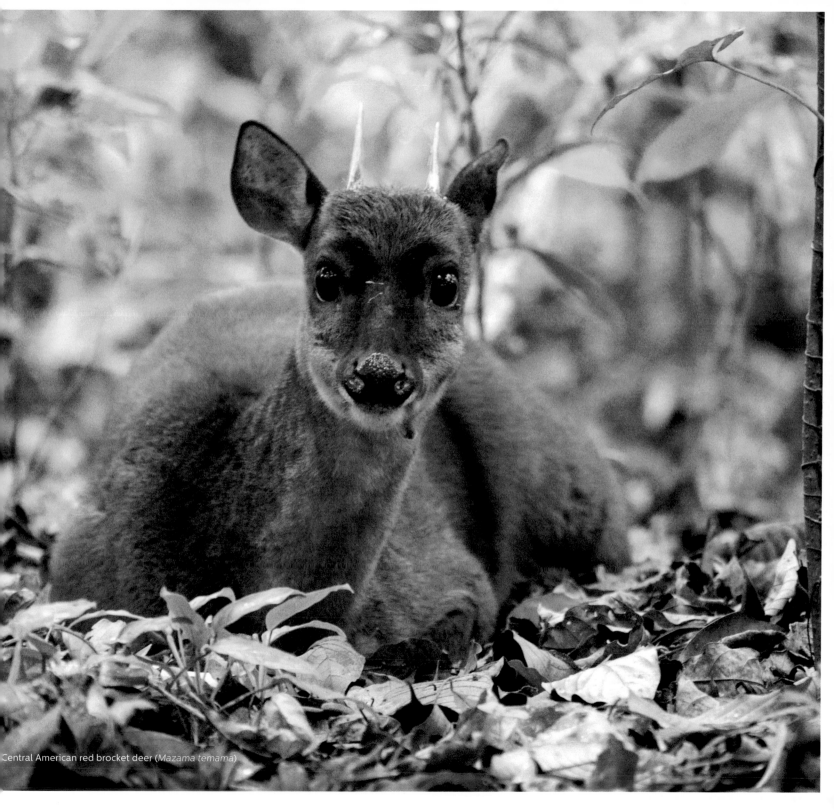

Central American red brocket deer (*Mazama temama*)

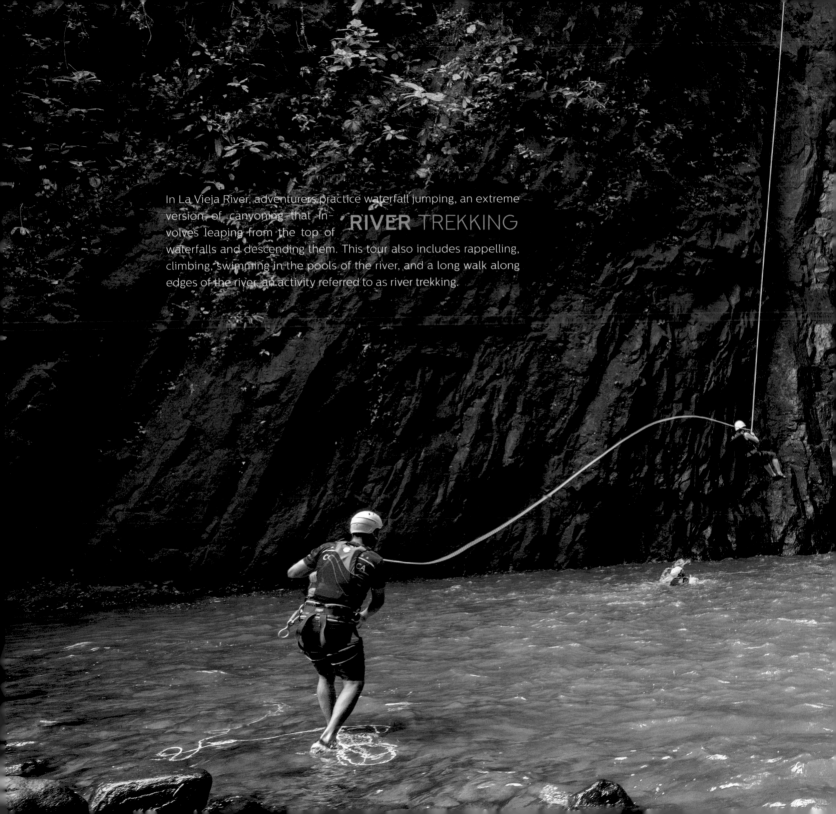

In La Vieja River, adventurers practice waterfall jumping, an extreme version of canyoning that in-volves leaping from the top of waterfalls and descending them. This tour also includes rappelling, climbing, swimming in the pools of the river, and a long walk along edges of the river, an activity referred to as river trekking.

RIVER TREKKING

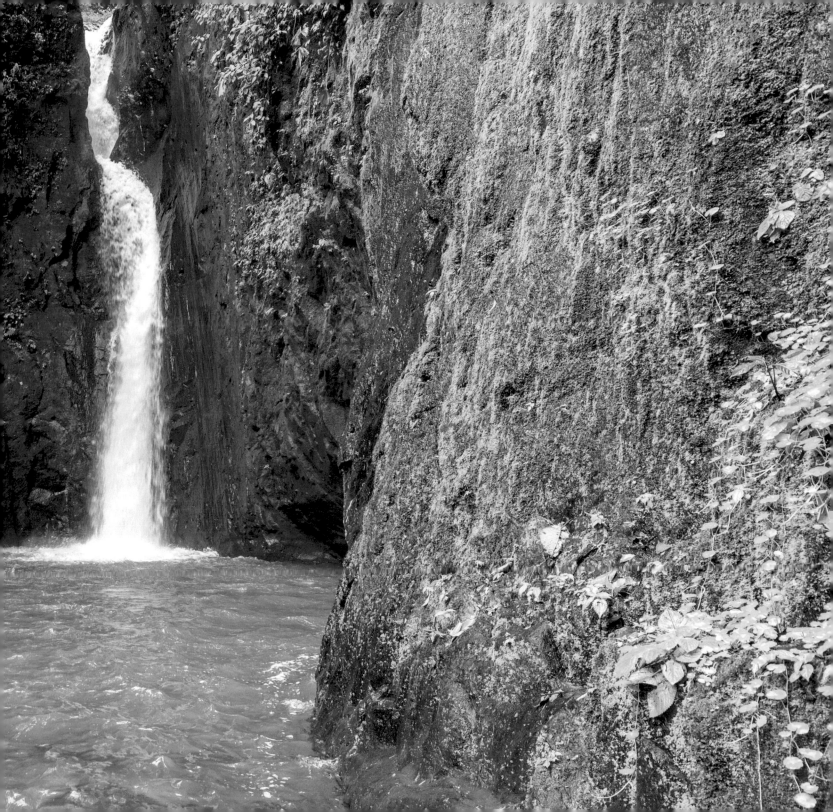

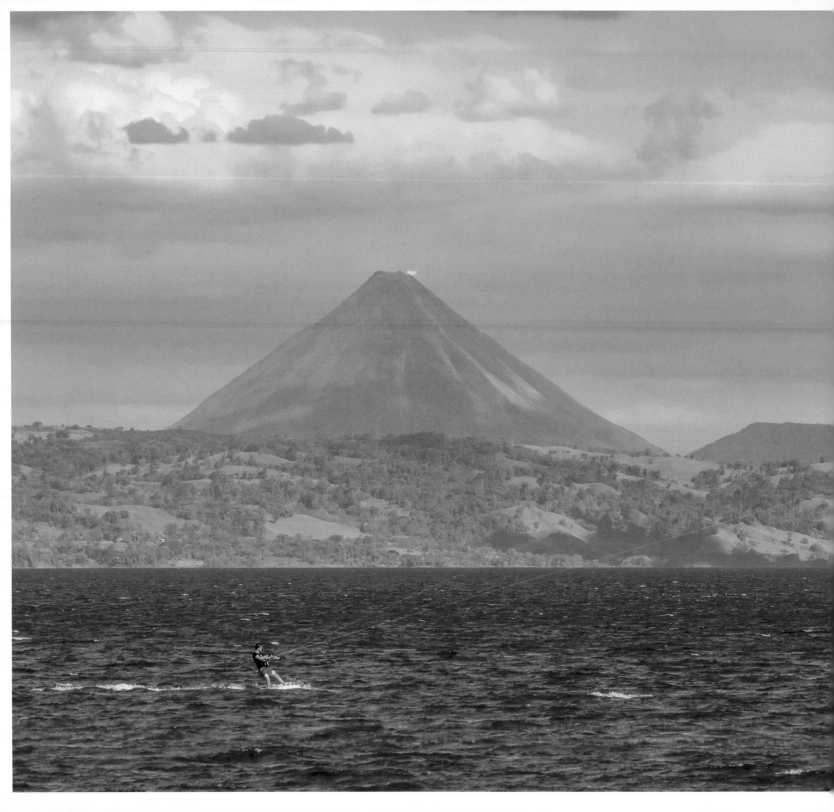

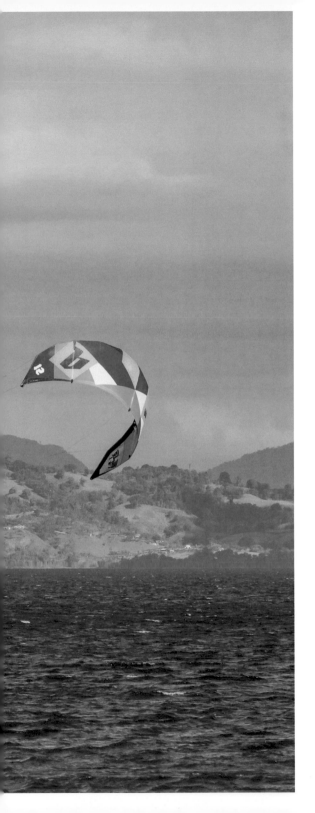

THE VOLCANO

Lake Arenal is one of two famous kitesurfing spots in Costa Rica, the other being Bahía Salinas in Guanacaste. Between December and March, when the trade winds gust, the average wind speed is 31 miles (50 km) per hour, conditions suitable only for experienced kitesurfers. During the rainy season, the wind speed decreases and the lake becomes the ideal place to learn this sport.

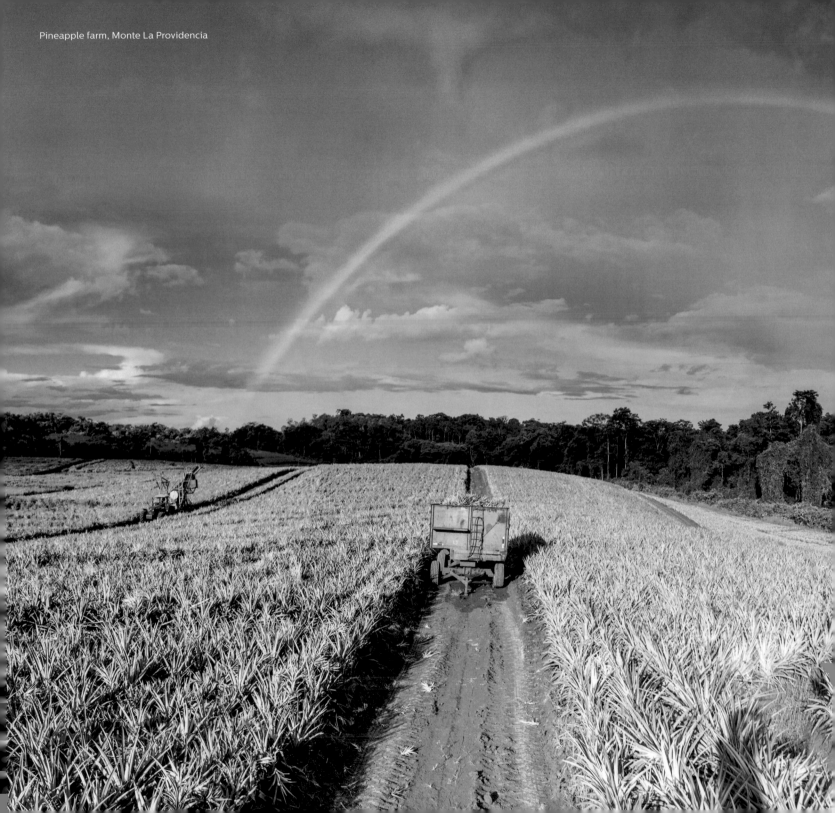

Pineapple farm, Monte La Providencia

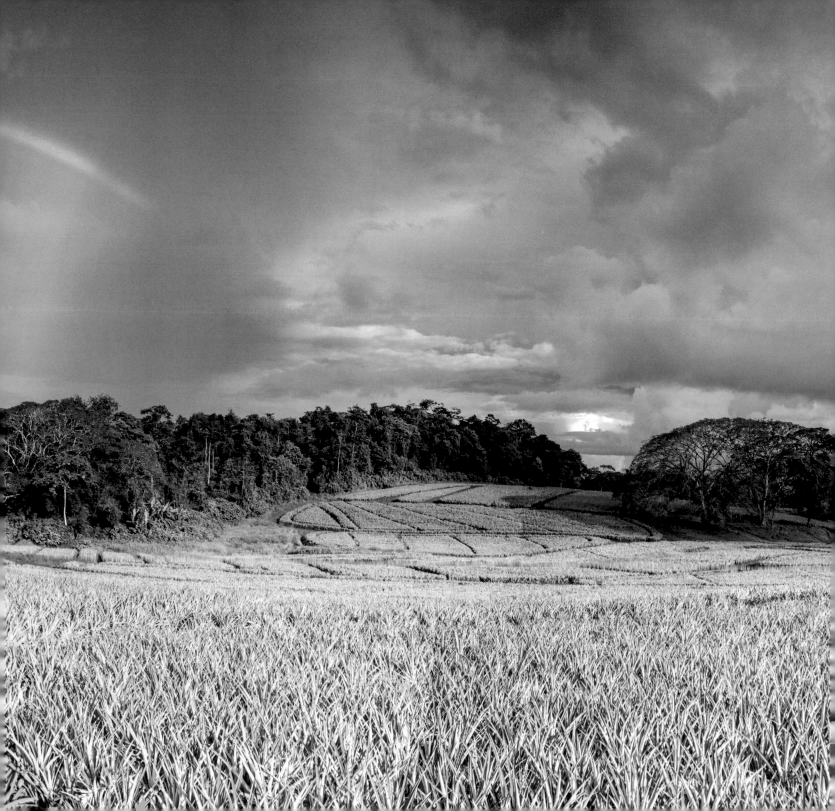

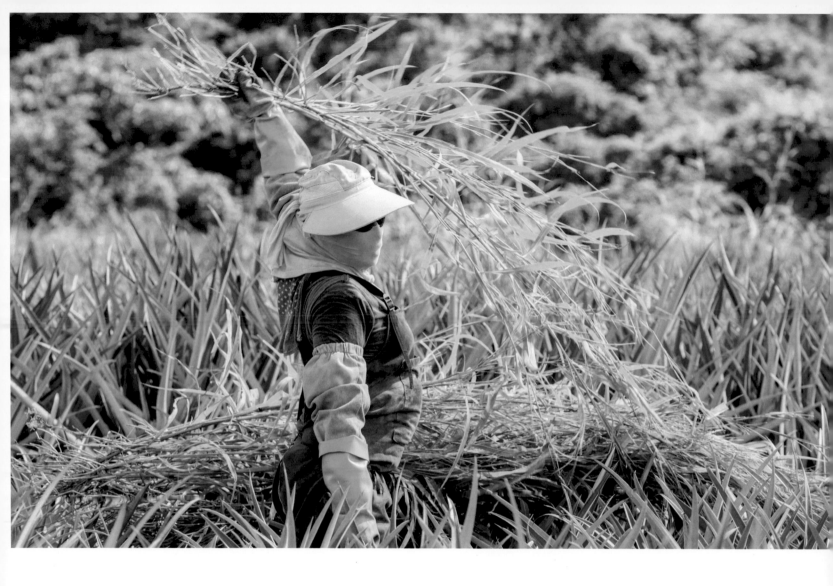

Costa Rica is the world's leading producer of pineapples, a crop that relies on the intensive use of highly toxic pesticides. The country's pineapple production occupies more than 123,550 acres (50,000 hectares), 53% of which is in the Caribbean plains. Finca Monte La Providencia is one of the few bright spots in this bleak panorama; it endeavors to produce pineapples in a way that is friendly to both people and the environment.

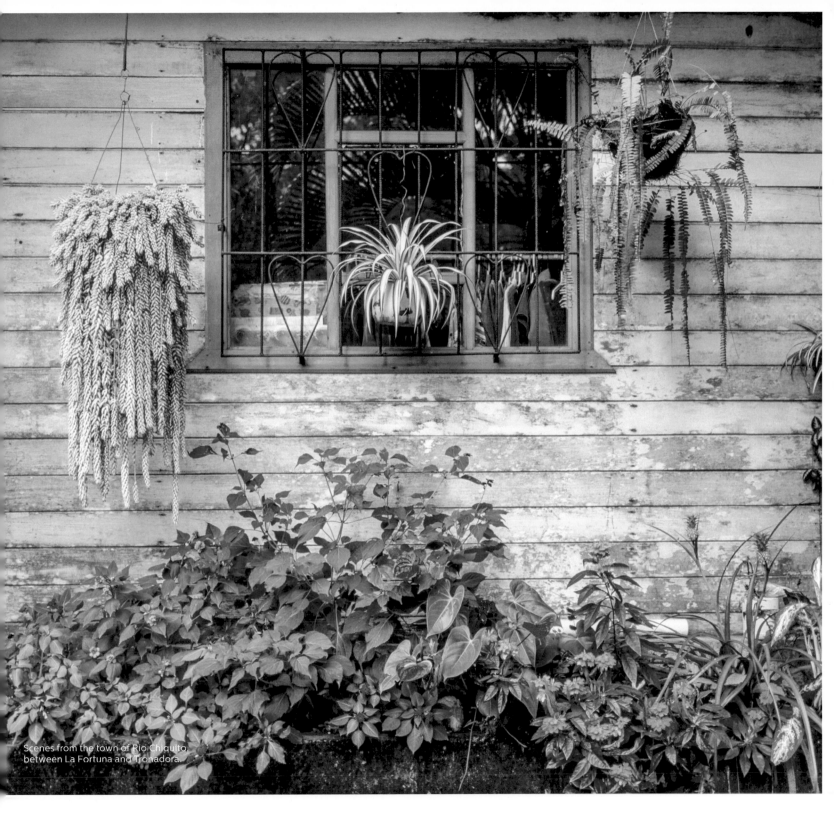

Scenes from the town of Río Chiquito, between La Fortuna and Tronadora.

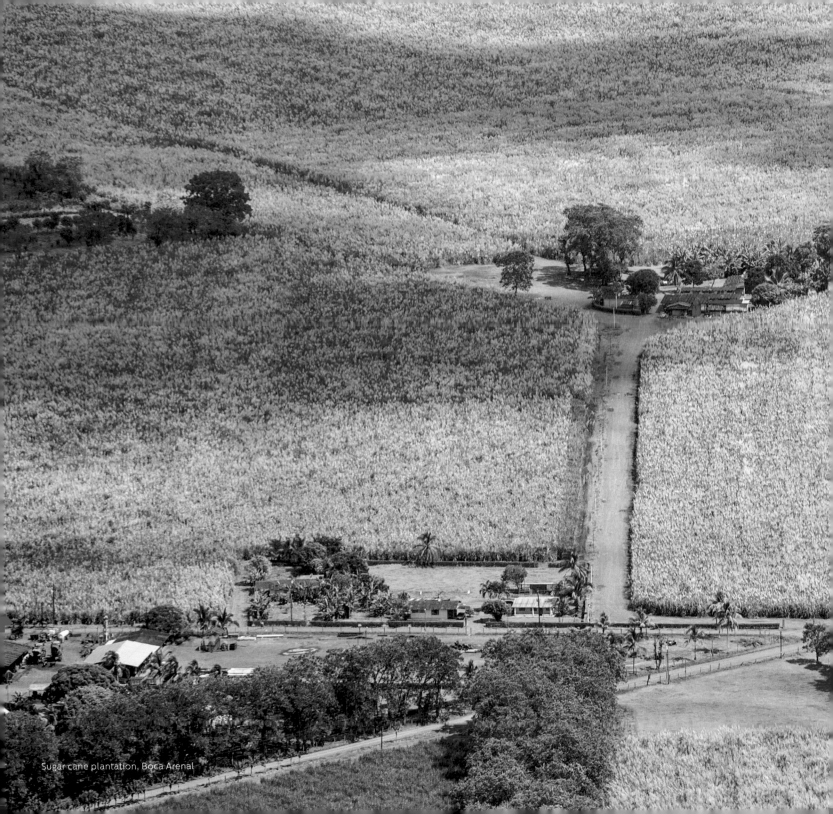

Sugar cane plantation, Boca Arenal

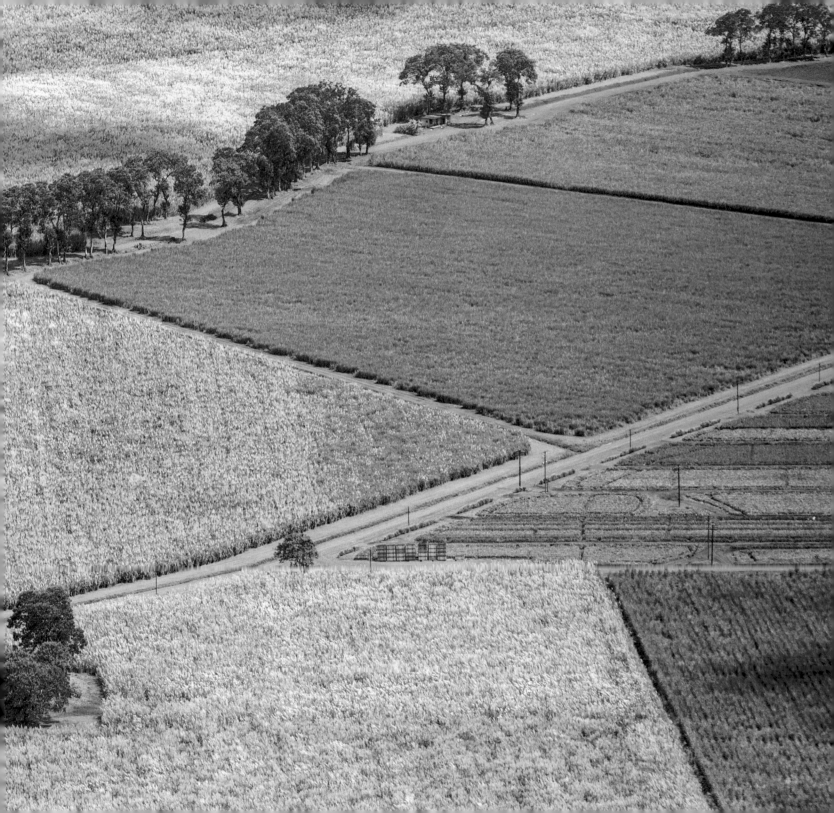

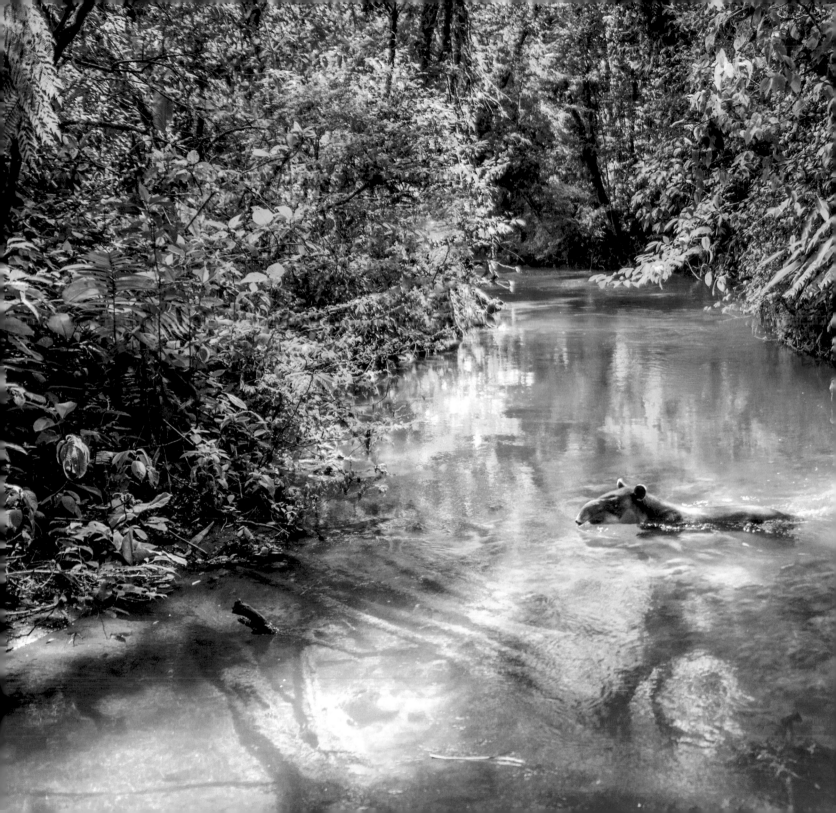

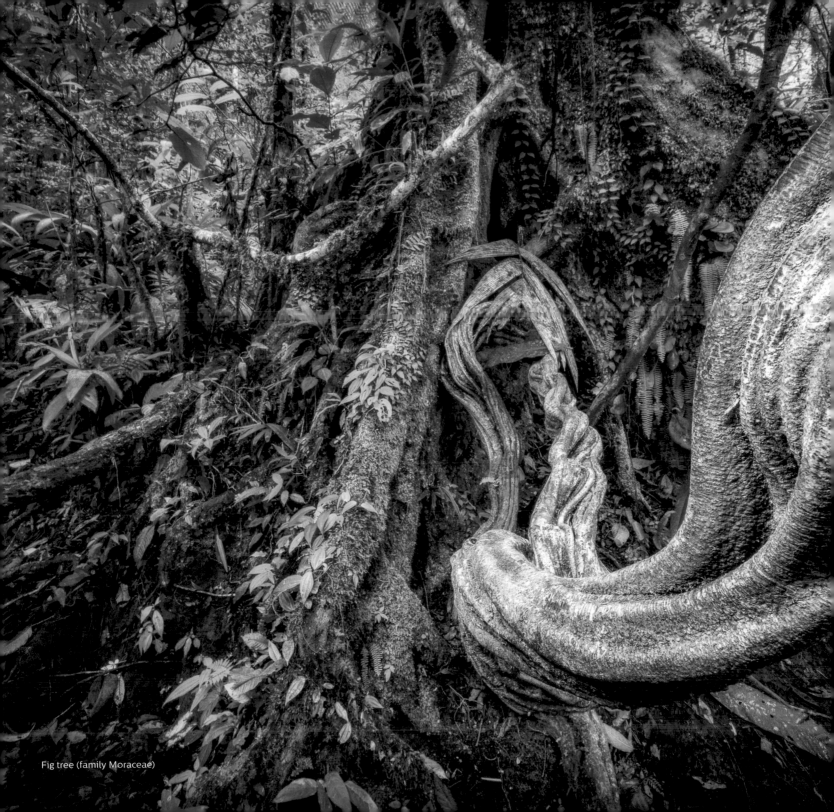

Fig tree (family Moraceae)

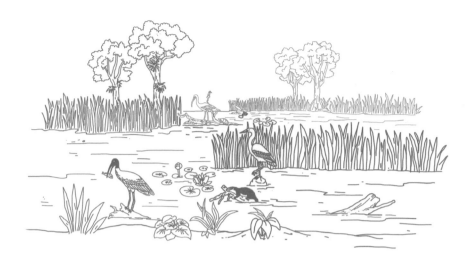

You might say that northern Costa Rica and southern Nicaragua are two different names for the same place, separated only by a border, a political fiction. The northern region of Costa Rica and the area southeast of Lake Nicaragua belong to the same biological entity—the watershed of the San Juan River, the largest body of fresh water in Central America. They form one of the richest wetland systems in the region.

Today, these plains, delineated by border lines, are composed of protected areas, national parks, indigenous territories, farming villages, and tracts of monoculture crops. Until the first half of the 20th century, they were almost completely isolated from the rest of Costa Rica, and thus their historical evolution was once linked more closely to Nicaragua than this country.

In the absence of highways to the Central Valley, the myriad rivers navigable toward the neighboring state served, for more than a century, as the exit route for resources taken from the region, especially rubber and timber.

The San Juan River, which essentially defines today's border between the two countries, began to lose importance as a trade route between them as a result of the Nicaraguan Revolution (1978–1979). The armed conflict to the north propelled the government of Costa Rica to more fully incorporate this long-neglected region into the "national project," and it built a network of roads, established utilities and ministerial offices, and promoted it as a new horizon for trade and economic prosperity. The policy would bring growth to the area but also have a dramatic impact on the surrounding ecosystems.

The last twenty years of the 20th century brought more changes to this area than the previous one hundred, as "development" effected through public policies, bank loans, and the creation of the first highways to Upala, Guatuso, and Los Chiles accelerated the transformation of tropical lowland wet forests—typical of the region—into pastures, cattle shelters, and a string of agro-industrial monoculture crops such as sugar cane, citrus, and pineapple. These changes greatly increased the amount of pollution in the environment.

Nearly 750,000 acres (300,000 hectares) of forest disappeared between 1985 and 1988. Although the pace of deforestation would decrease—and the area slowly began to regenerate in the following decades—the region had experienced a precipitous decline, comparable only to that of the Amazonian rainforest.

It is not surprising that, at the dawn of the 21st century, the extraordinary biodiversity of this tropical region, where land and sky are connected through the flight pattern of migratory birds, would experience a political-environmental crisis whose "local disturbances" would soon become national conflicts.

The battle against open-pit mining was one of the most visible examples of this. Its peak was in 2010, with the well-known "Crucitas Case," in which miners aimed to extract gold on about 750 acres (300 hectares) of the La Fortuna and Botija mountains, in San Carlos. This would have affected sections of the San Juan-La Selva Biological Corridor, the site of important conservation efforts for the great green macaw (*Ara ambiguus*).

Despite the fact that its mahogany (*Swietenia macrophylla*) and tonka bean (*Dipteryx panamensis*) forests have been largely decimated, its water resources endangered, its mineral deposits disputed, and that inhabitants such as the paca, tapir, and puma are under threat of extinction, this region is still one of the richest in the country.

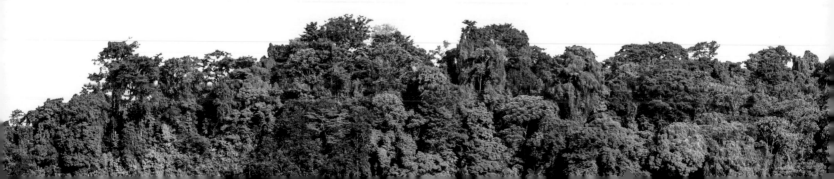

This area continues to protect its natural heritage in national parks and wildlife reserves. These include the San Juan-La Selva Biological Corridor, the Costa Rica-Nicaragua Border Corridor, and the Arenal, Maquenque, Medio Queso, and Caño Negro wetlands. The latter is considered the third most important wetland in the world, because it hosts and feeds an extraordinary number of birds, over 320 species.

Just barely 15 miles (25 km) from Lake Nicaragua, the Caño Negro Wildlife Refuge is a giant stretch of lowland, seasonal lakes that spends most of the year submerged, although in the dry season, from January to April, this landscape is reduced to a few small lakes and barren shores. This wildlife refuge also houses raffia palm (*Raphia taedigera*) and *cedro maría* (*Calophyllum brasiliense*) forests; both species are typical of this region and, especially in the dry season, can harbor a diverse community of birds and mammals, from ocelots and peccary to jaguars and harpy eagles, all under threat from deforestation.

In the rainy season, its waters often merge with the Río Frío, creating a unique habitat that offers food and shelter for thousands of resident and migratory birds, including the lesser scaup, osprey, bare-throated tiger heron, Neotropic cormorant, the elegant but threatened jabiru stork, and the Nicaraguan grackle, a bird endemic to the Lake Nicaragua watershed.

From the tops of the Tenorio and Miravalles volcanoes, one looks onto the expansive San Carlos plains, Lake Nicaragua, and Caño Negro, all that remain of the land of the Maleku, the smallest surviving indigenous group in the northern part of the country. They live in the *palenques* (communities) of El Sol, Margarita, and Tonjibe.

The culture of the Maleku, or Guatusos, dates back some 4000 years. At one time, they inhabited the Río Frío watershed, controlling nearly 250,000 acres (100,000 hectares), from Tenorio Volcano to the San Juan River. They were worshipers of water—and all sites

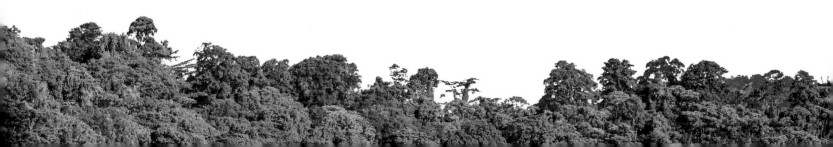

Passerini's tanager (*Ramphocelus passerinii*)

associated with it—as their gods were said to reside at the source of the rivers, where the mountains are covered by clouds.

In their cosmology, every spring, river, and lake was the realm of a god. During the centuries before their contact with Europeans, water was not only the source of their religious beliefs, it determined the location of their communities (to facilitate fishing and cultivation of crops) and inspired the naming of certain places.

Their main deity, the One from the Headwaters of the Nharíne ("Deer River" in English), destroyed his own creation with a flood, at the insistence of the Goddess of the Headwaters of the Aóre River ("Dead River" in English), who had always wished for the destruction of humanity. After the powerful flood, the Goddess Aóre "was unable to create anything but harmful or useless species of plants and animals," and as a result the god Nharíne had to reintroduce humans, which he made arise from caves.

In the mid-19th century, the Maleku still considered the thousands of acres along the Río Frío theirs, but this changed radically after the first permanent contact with non-indigenous people. Their extermination began in 1868, with the arrival of Nicaraguan rubber tappers who, for over 30 years, dedicated themselves to subjugating and robbing them, and in the process infecting them with diseases. They were brutally trafficked and enslaved, as well as exploited as labor to extract wild latex from the Panama rubber tree (*Castilla elastica*). Had it not been for the intervention, in 1882, of Bernardo Augusto Thiel, a Costa Rican bishop of German origin, this genocide would have resulted in the total disappearance of the Maleku.

After several trips to Nicaragua, political maneuvering in both countries, and earthly, if not heavenly, interventions, Thiel was able to reduce cases of abuse. At the dawn of 1900s, there was a boom of rubber plantations in Southeast Asia, and the butchery in Costa Rica came to a complete halt.

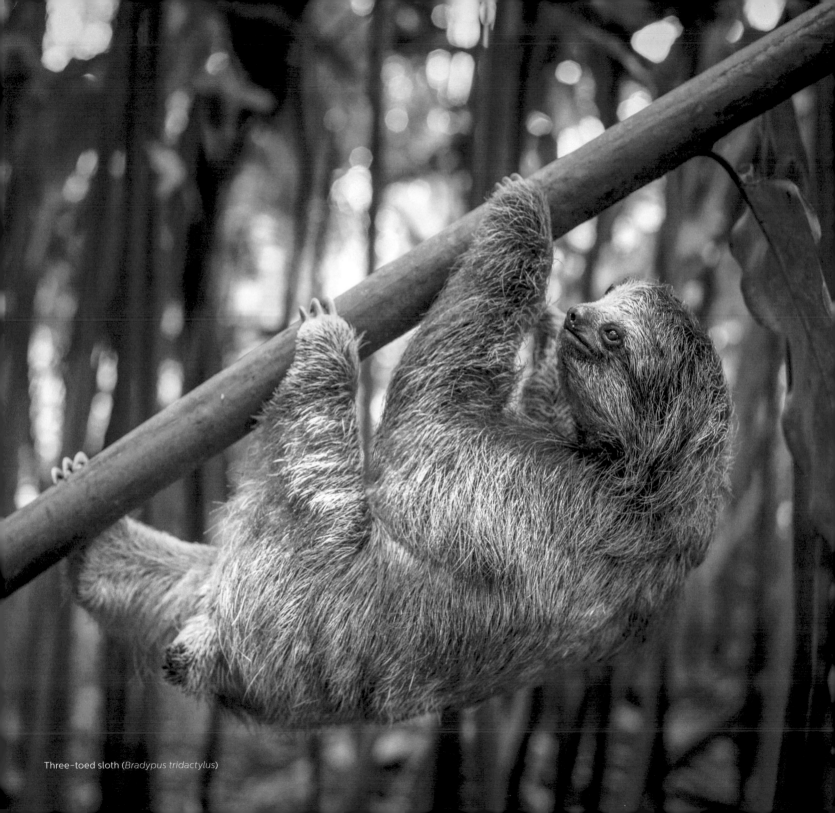

Three-toed sloth (*Bradypus tridactylus*)

Today, a tiny population of no more than 1000 people lives in the Maleku Indigenous Reserve, in Guatuso. Their kingdom has been reduced to three communities—El Sol, Margarita, and Tonjibe—on land of less than 1500 acres (600 hectares). In doorways, women and men spin purses or carve *jicaras* (tree gourds), while the children look out over ponds of greenish waters, where turtles and fish raised for consumption float idly.

Coursing through the dense vegetation of Tenorio Volcano and its silent craters, tumbling down slopes over the centuries, is a turquoise jewel, the Río Celeste, whose unreal colors seem to give proof to the Maleku belief in the divine origin of rivers. One of the biggest attractions in the region, tourists arrive as though on a pilgrimage. The hallucinatory hues of the river—and the contrast between the pale blue water and the intense emerald greens of the surrounding forest—give the landscape an unreal aspect.

The Río Celeste occurs at the junction of the Agria Stream and the Buena Vista River, a point known as *Los Teñideros* (the place where things are dyed). The waters carry aluminum silicate particles, which reflect only the blue part of the light spectrum, giving the river its fantastic coloration.

Tenorio Volcano is actually a set of four cones, distributed over 140 miles (225 km), on the southern limit of the Guanacaste Mountain Range. The mountains act as a barrier; as clouds from the Caribbean move west, loaded with moisture and buffeted by trade winds out of the northwest, they unload intense rains on the region.

The landscapes of this region are all shaped by water, whether it falls from the sky or springs from the earth, a scientific reality that coincides with the mythological worldview of the Maleku.

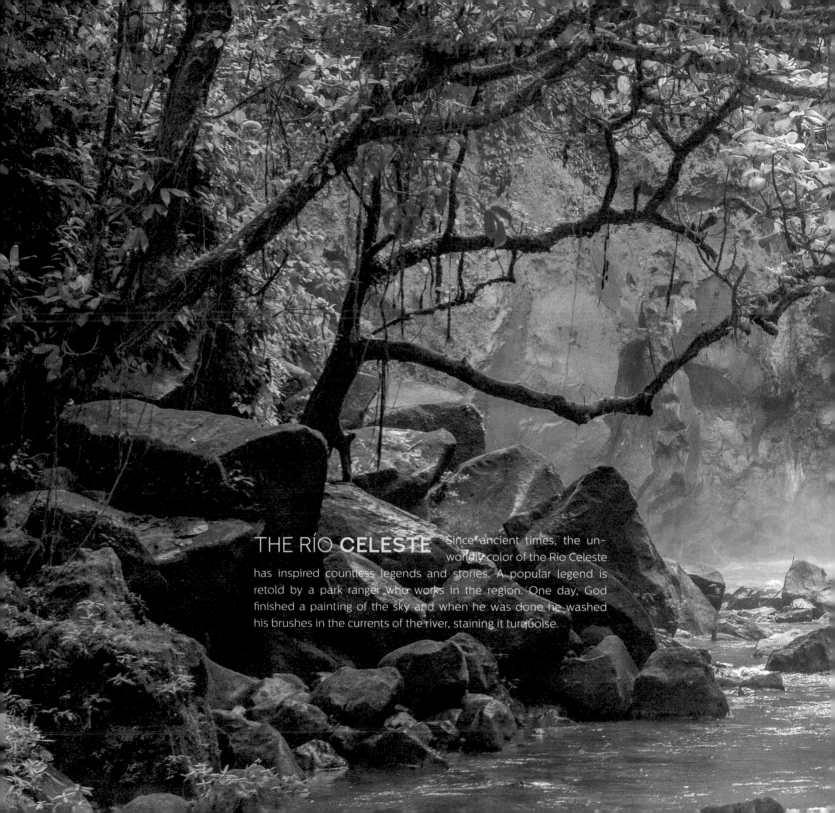

THE RÍO **CELESTE**

Since ancient times, the unworldly color of the Rio Celeste has inspired countless legends and stories. A popular legend is retold by a park ranger who works in the region. One day, God finished a painting of the sky and when he was done he washed his brushes in the currents of the river, staining it turquoise.

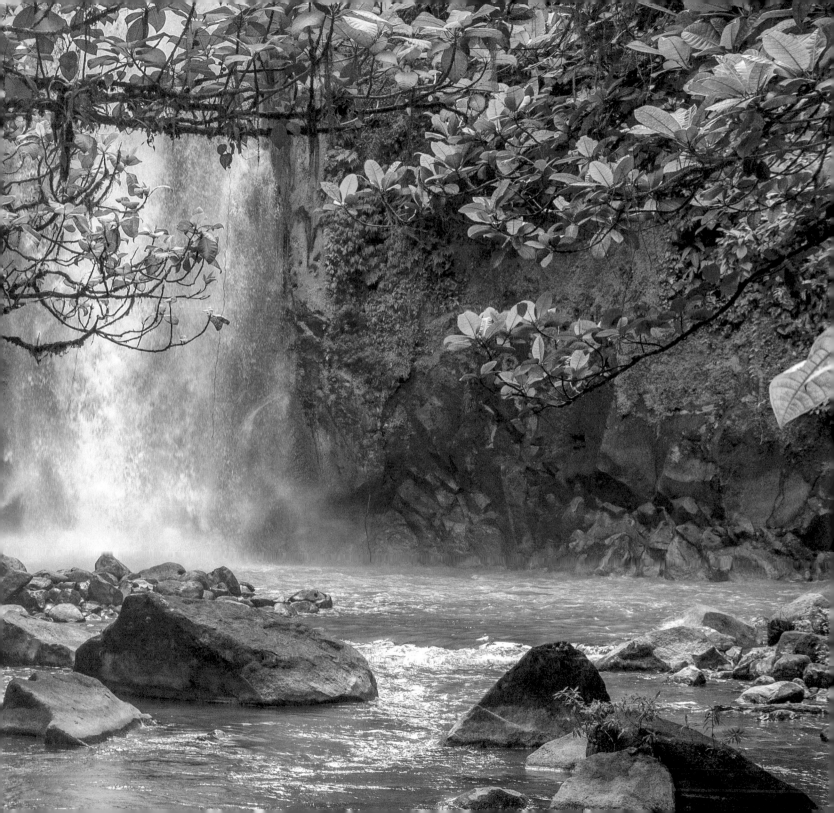

THE TURQUOISE GEM

Contrary to popular lore, the color of this river is not due to the intervention of some divinity. It results, scientists note, from the conjunction of a stream that has high acidity with the Río Celeste, which contains aluminum silicates. This mixture generates particles of a specific dimension capable of reflecting the blue light that colors this remarkable river.

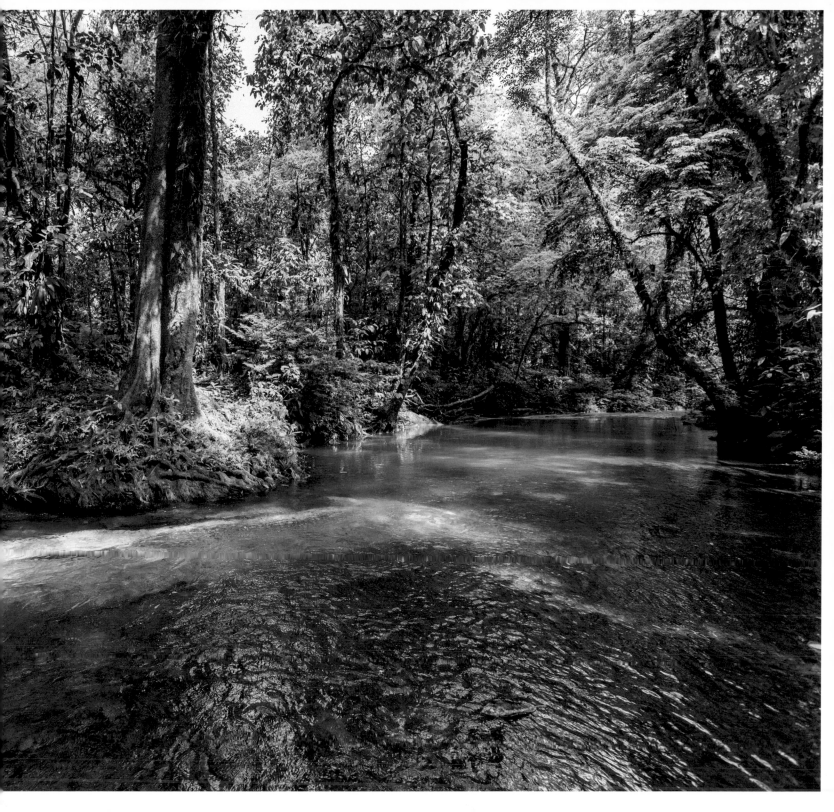

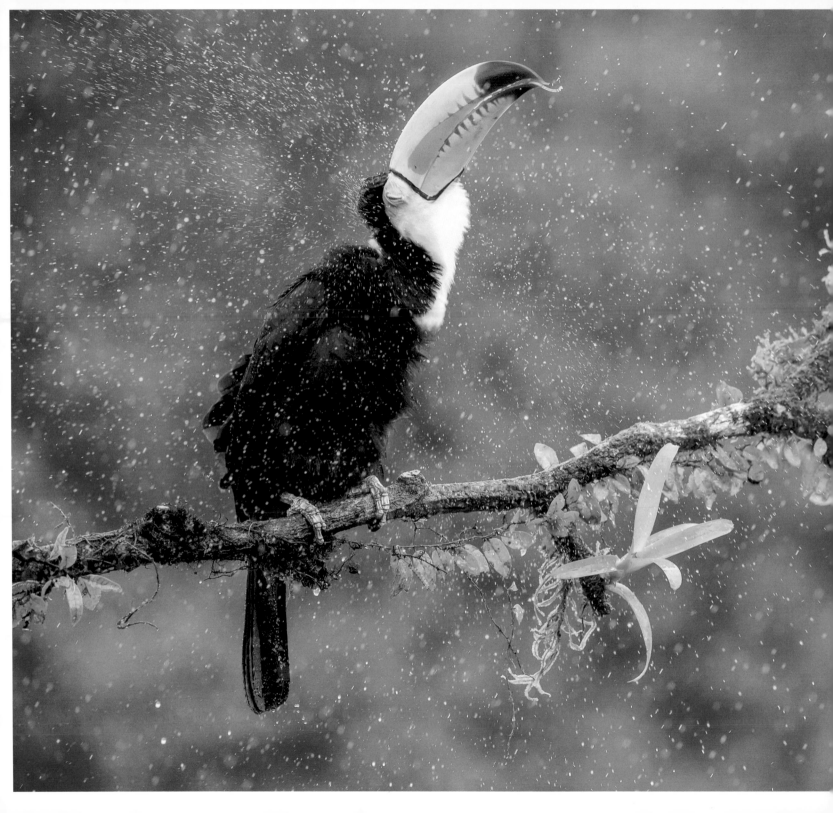

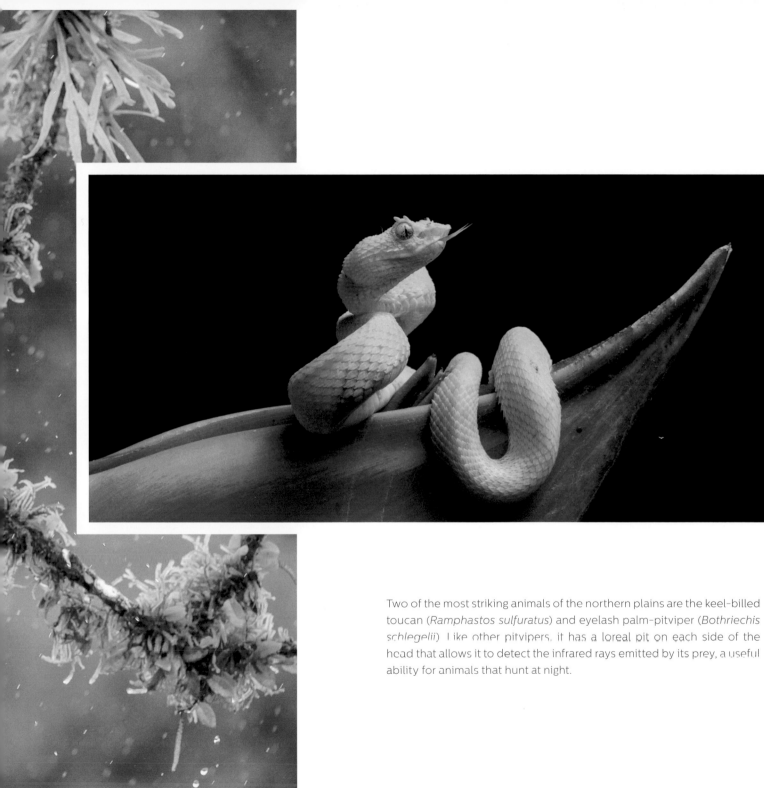

Two of the most striking animals of the northern plains are the keel-billed toucan (*Ramphastos sulfuratus*) and eyelash palm-pitviper (*Bothriechis schlegelii*). Like other pitvipers, it has a loreal pit on each side of the head that allows it to detect the infrared rays emitted by its prey, a useful ability for animals that hunt at night.

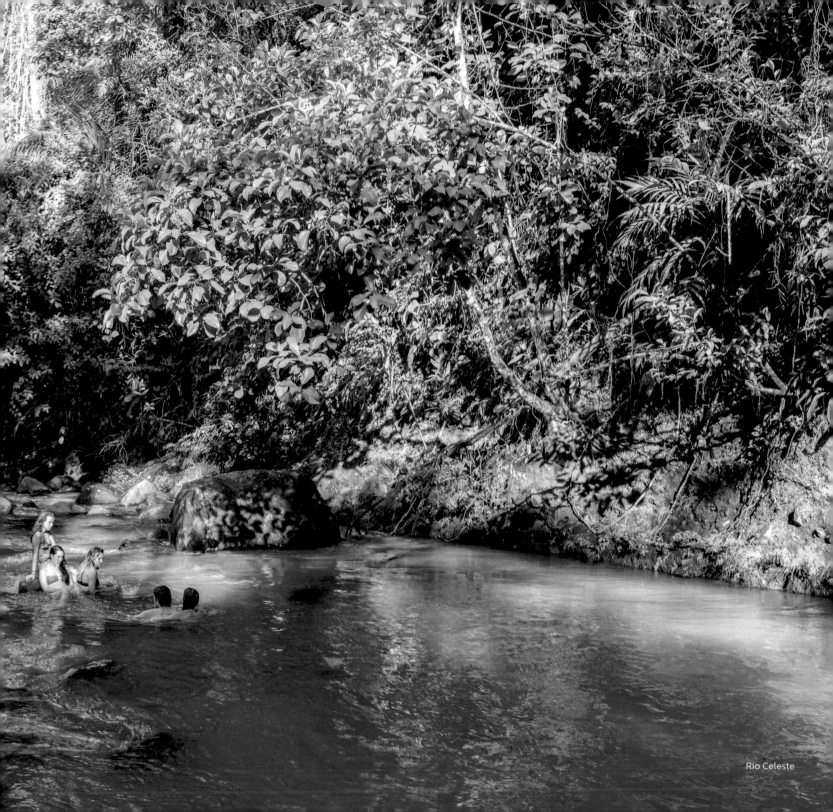

Rio Celeste

THE WETLANDS

The plains of the northern zone contain 60% of the country's wetlands. Large areas flooded during the rainy season provide habitat for hundreds of species, especially birds, both migrant and resident species. The two largest wetlands are Medio Queso and Caño Negro, but Maquenque and Boca Tapada are also paradises for birdwatchers.

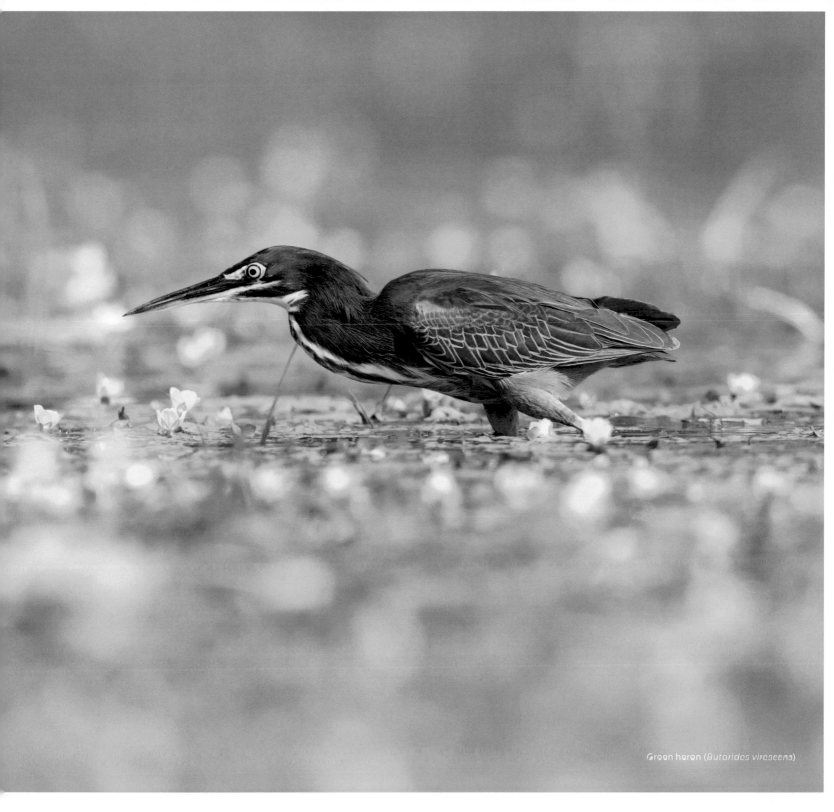

Green heron (*Butorides virescens*)

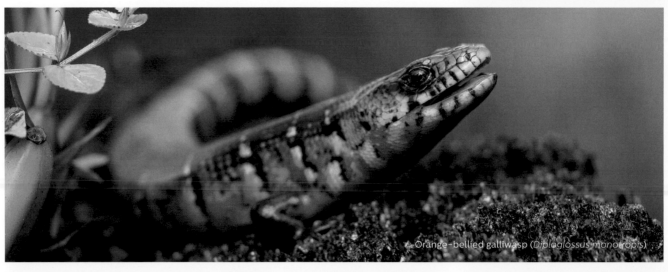

Orange-bellied galliwasp (*Diploglossus monotropis*)

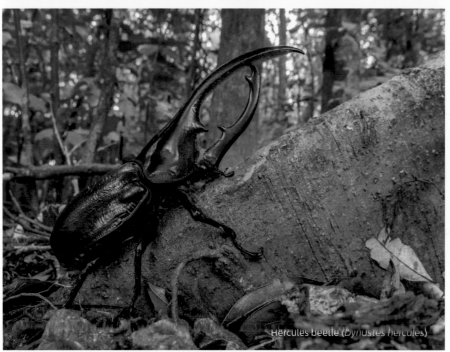

Hercules beetle (*Dynastes hercules*)

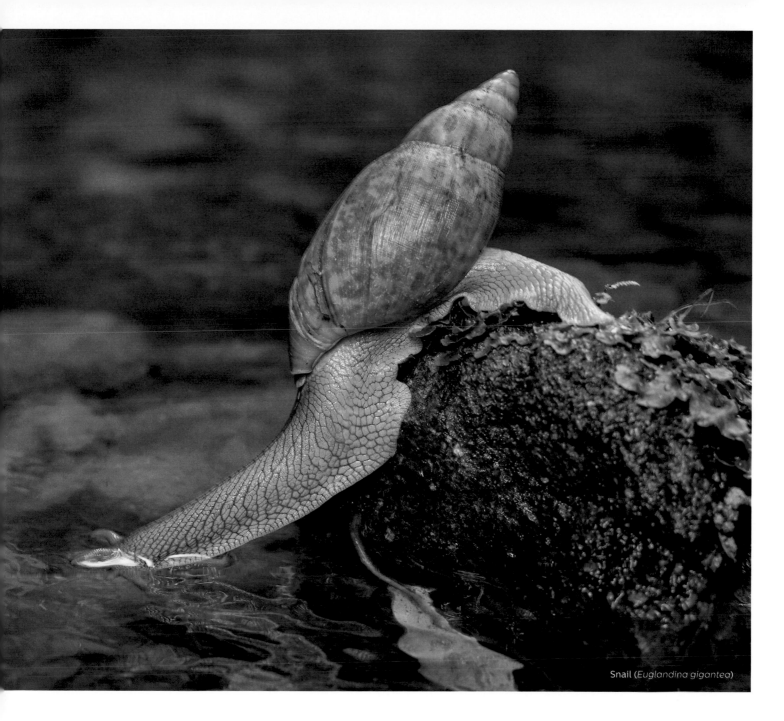

Snail (*Euglandina gigantea*)

Sometimes it is the smallest forest inhabitants that have the most striking colors and shapes, among them insects, mollusks, and small reptiles.

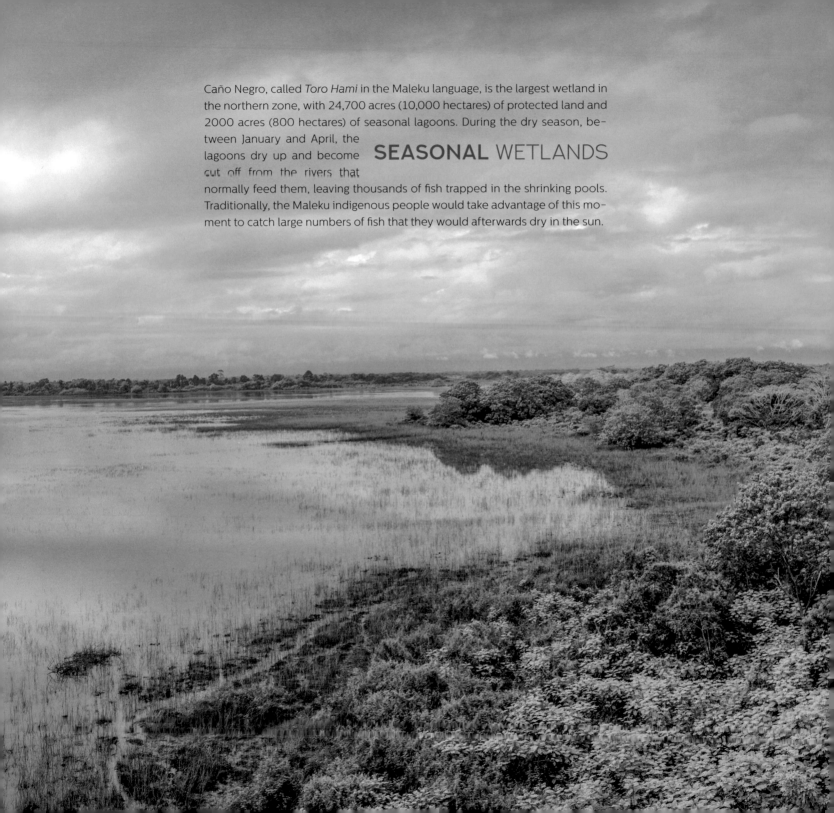

Caño Negro, called *Toro Hami* in the Maleku language, is the largest wetland in the northern zone, with 24,700 acres (10,000 hectares) of protected land and 2000 acres (800 hectares) of seasonal lagoons. During the dry season, between January and April, the lagoons dry up and become cut off from the rivers that **SEASONAL** WETLANDS normally feed them, leaving thousands of fish trapped in the shrinking pools. Traditionally, the Maleku indigenous people would take advantage of this moment to catch large numbers of fish that they would afterwards dry in the sun.

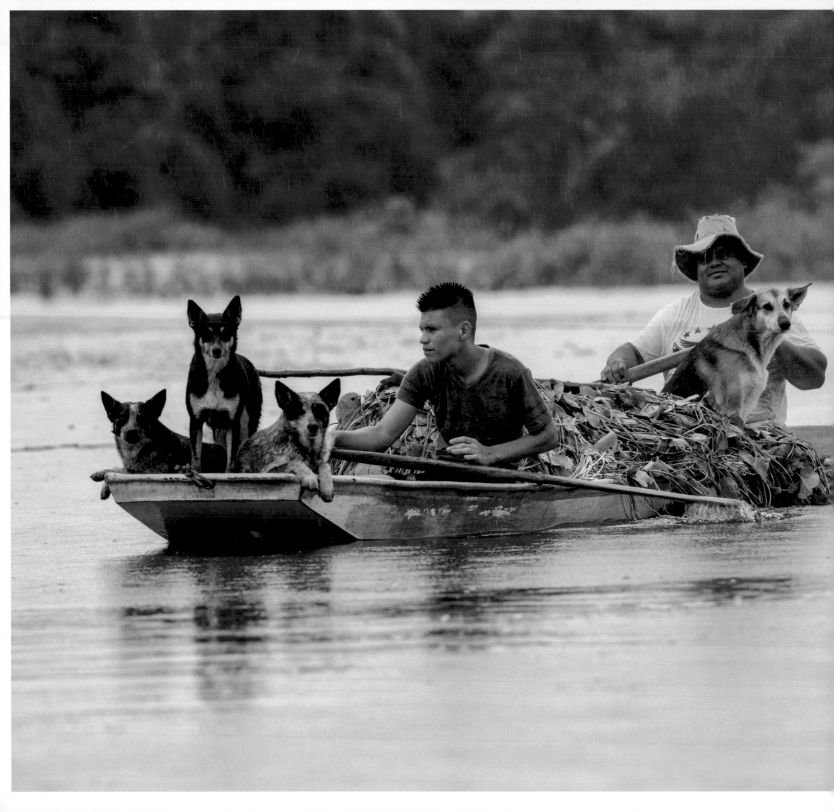

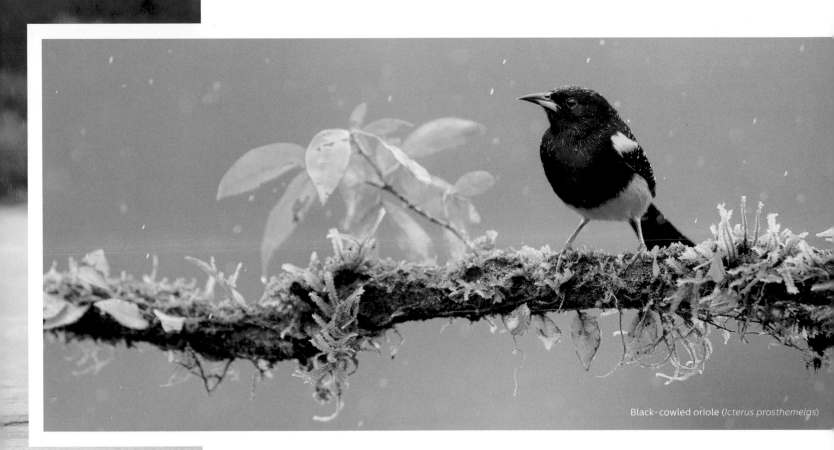

Black-cowled oriole (*Icterus prosthemelas*)

In Caño Negro, rain is often a constant companion of daily life that rarely alters the routine of people who live here. The 177 inches (4500 mm) of annual rainfall feed the channels and lagoons, guaranteeing the stability of the ecosystem. In the past ten years, however, climate change has extended the length of dry periods, and decreased water levels.

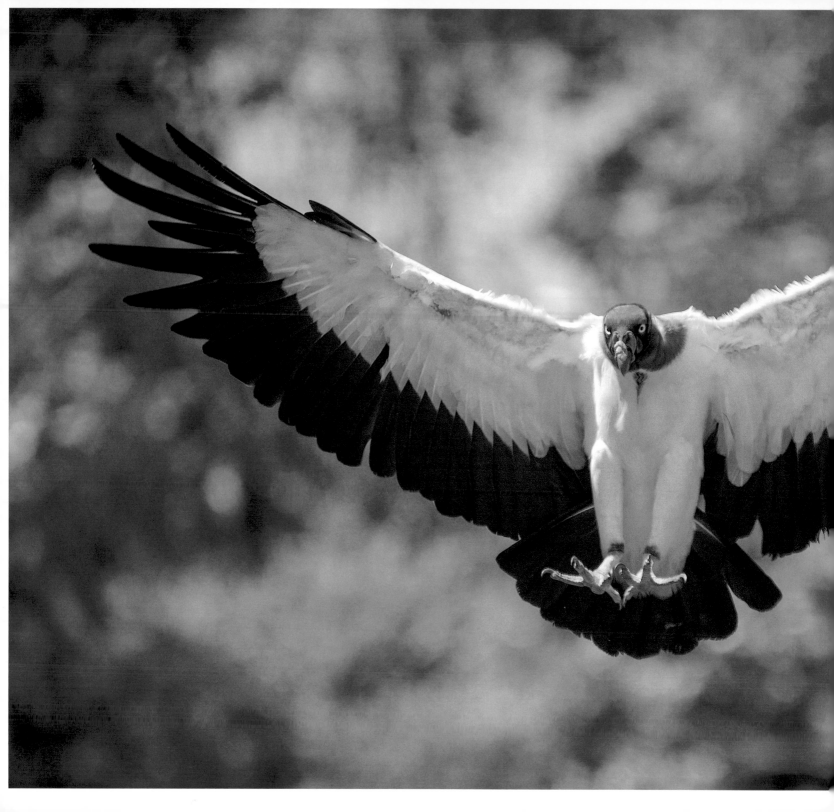

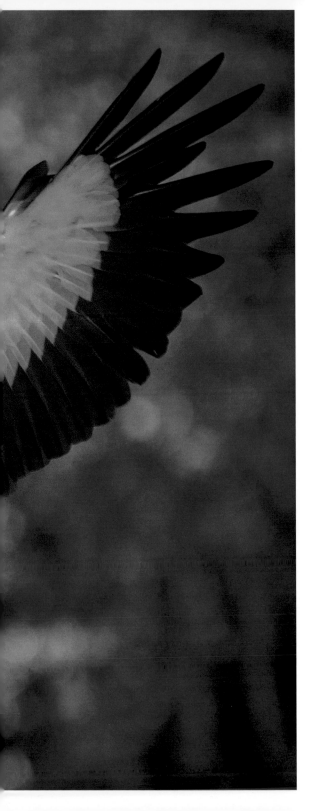

THE
KING

Said by the Maya to be a messenger between the gods and human beings, the king vulture (*Sarcoramphus papa*) is the largest and most colorful of the vultures that live in Central America. An inhabitant of humid lowland forests, it is generally difficult to observe. That is why in Boca Tapada and Maquenque many hotels have built observation shelters where they put out pig or cow heads to attract these scavengers and bring them within range of cameras.

THE SUNBITTERN

The sunbittern (*Eurypyga helias*) builds its nest in branches hanging over rivers and lagoons. The female and male share the task of raising their chicks and stand guard at the nest. When a predator approaches, the adult on duty pretends to be wounded, opening its wings and dragging them on the ground, to attract the attention of the predator. With a series of brief flights, the adult then flies away from the nesting site, and away from danger.

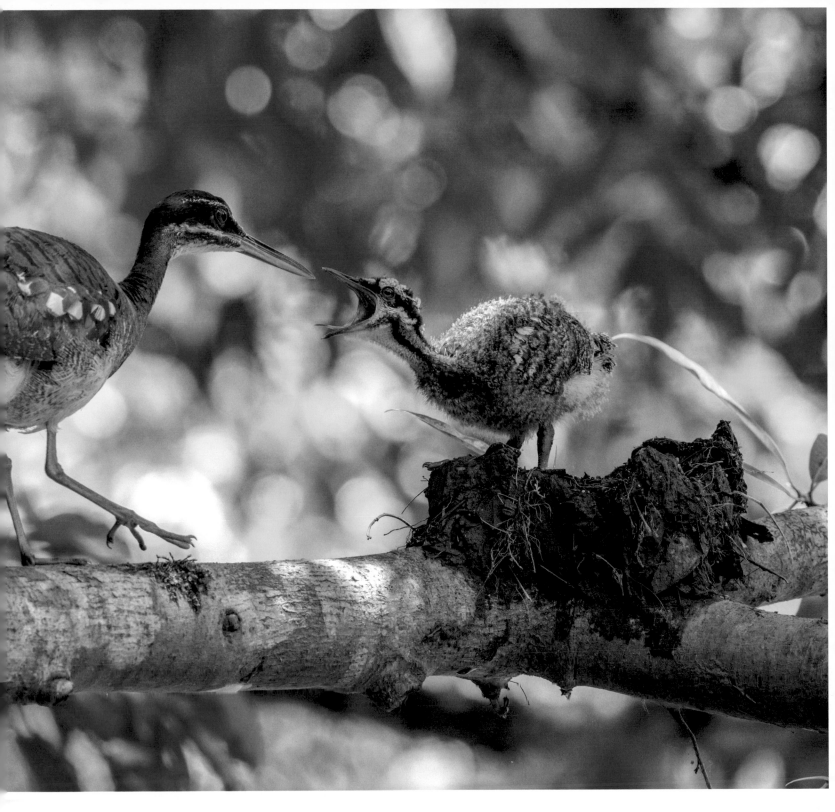

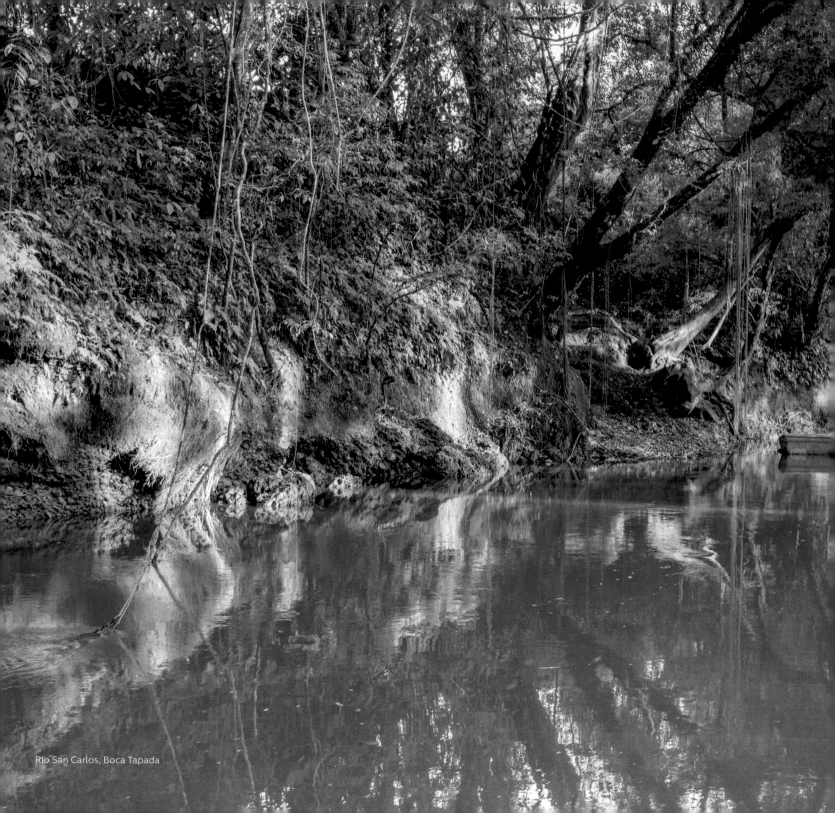

Río San Carlos, Boca Tapada

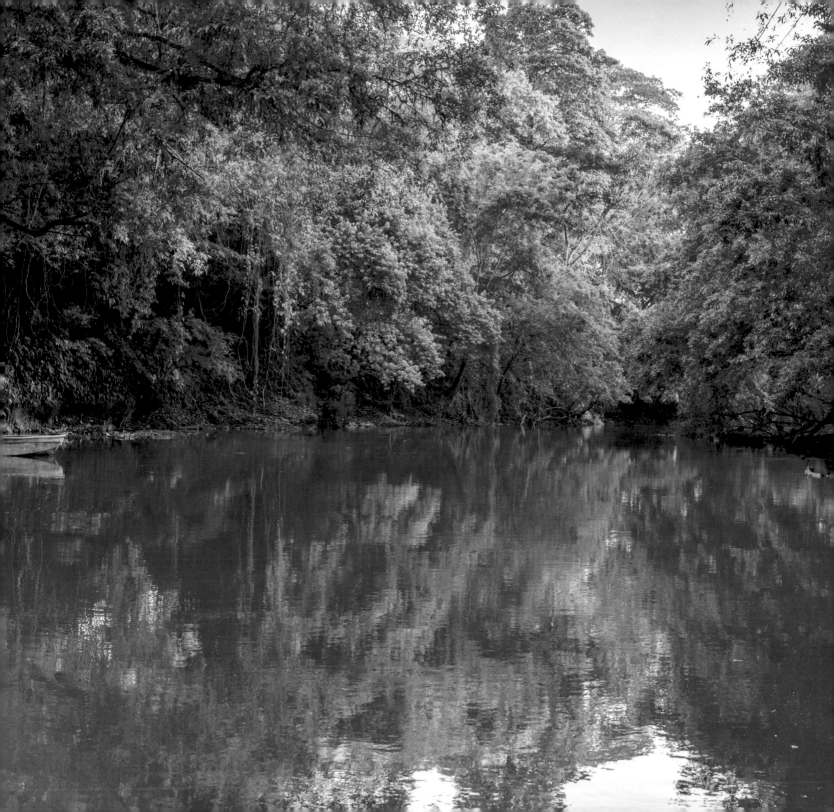

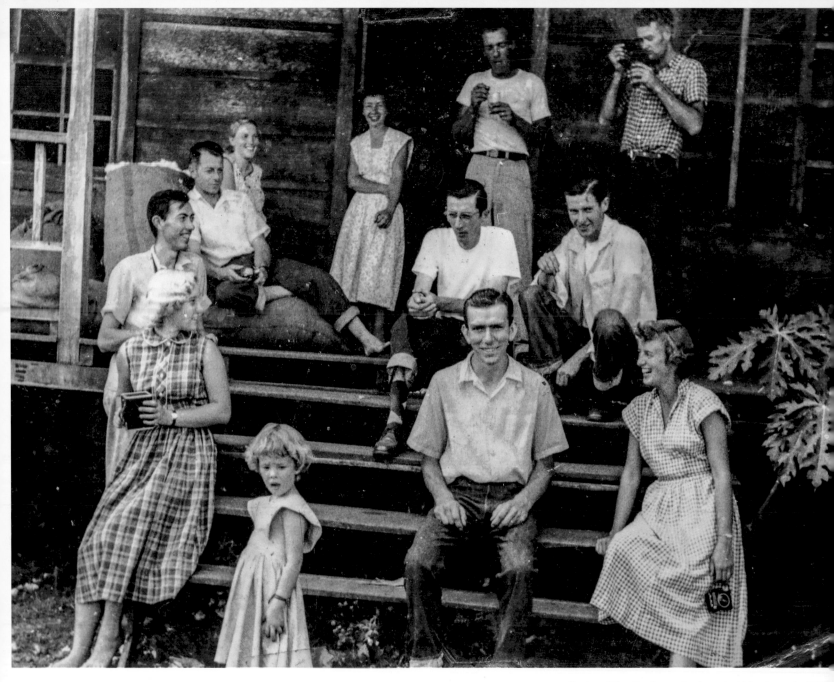

Some of the Quakers who founded Monteverde, 1957.

INDEX

CREDITS

PHOTOGRAPHERS

Unless indicated below, all photographs
are by Luciano Capelli.
Gregory Basco: pp. 16, 54, 55, 57, 78, 80,
92, 93, 98 (top), 103
Mauricio Valverde: pp. 2, 34, 35, 99
Pepe Manzanilla: pp. 22, 23, 102, 107
Jorge Chinchilla: pp. 29 up, 64, 97
Alvaro Cubero: pp. 17, 86, 104
Félix Salazar: pp. 36, 37
Jeffrey Muñoz: pp. 42, 56
John Campbell: p. iv
Joy Murillo: p. 65
James Keiser: p. 68
Jen Guyton: p. 98 (bottom)

COVER PHOTOS

Diego Mejías,
Jeffrey Muñoz

LAYOUT DESIGN & PHOTO RETOUCHING

Francilena Carranza

LOGO, MAP & ILLUSTRATIONS

Elizabeth Argüello

ORIGINAL TEXT

María Montero,
Luciano Capelli

ENGLISH ADAPTATION

Noelia Solano,
John Kelley McCuen

TEXT REVIEW

John Kelley McCuen,
Stephanie Monterrosa

CONCEPT

Luciano Capelli,
Stephanie Monterrosa,
John Kelley McCuen

PRODUCTION

Luciano Capelli,
John Kelley McCuen

PRODUCTION ASSISTANT

Stephanie Monterrosa

ABOUT
THE
PUBLISHERS
—

Cornell University Press fosters a culture of broad and sustained inquiry through the publication of scholarship that is engaged, influential, and of lasting significance. Works published under its imprints reflect a commitment to excellence through rigorous evaluation, skillful editing, thoughtful design, strategic marketing, and global outreach. The Comstock Publishing Associates imprint features a distinguished program in the life sciences (including trade and scholarly books in ornithology, botany, entomology, herpetology, environmental studies, and natural history).

Ojalá publishes illustrated books about the biodiversity and cultural identity of Costa Rica. With every title, we strive to intertwine images and text to transport readers on a voyage through this extraordinary country.

Zona Tropical Press publishes nature field guides and photography books about Costa Rica and other tropical countries. It also produces a range of other products about the natural world, including posters, books for kids, and souvenirs.

COSTA RICA REGIONAL GUIDES

GUANACASTE

MARIA MONTERO AND LUCIANO CAPELLI

MONTEVERDE & ARENAL

MARIA MONTERO AND LUCIANO CAPELLI

CARIBBEAN COAST

YAZMIN ROSS AND LUCIANO CAPELLI

CENTRAL VALLEY

AVAILABLE IN 2020

MANUEL ANTONIO

AVAILABLE IN 2020

OSA & CORCOVADO

AVAILABLE IN 2020

Principal font: Centrale Sans